CREATIVE OPTICAL & DIGITAL

Filter
TECHNIQUES

CREATIVE **OPTICAL & DIGITAL**

Filter
TECHNIQUES

Joseph Meehan

LARK
PHOTOGRAPHY
BOOKS

A Division of Sterling Publishing Co., Inc.
New York / London

Editor: Haley Pritchard
Book Design: Thom Gaines
Cover Design: Thom Gaines

Library of Congress Cataloging-in-Publication Data

Meehan, Joseph.
 Creative optical & digital filter techniques / Joseph Meehan. -- 1st ed.
 p. cm.
 Includes index.
 ISBN 978-1-60059-580-6
 1. Photography--Light filters. I. Title. II. Title: Creative optical and digital filter techniques.
 TR590.5.M43 2010
 771.3'56--dc22

 2009048854

10 9 8 7 6 5 4 3 2 1

First Edition

Published by Lark Books, A Division of
Sterling Publishing Co., Inc.
387 Park Avenue South, New York, N.Y. 10016

Distributed in Canada by Sterling Publishing,
c/o Canadian Manda Group, 165 Dufferin Street
Toronto, Ontario, Canada M6K 3H6

Distributed in the United Kingdom by GMC Distribution Services, Castle Place, 166 High Street,
Lewes, East Sussex, England BN7 1XU

Distributed in Australia by Capricorn Link (Australia) Pty Ltd., P.O. Box 704, Windsor, NSW 2756
Australia

If you have questions or comments about this book, please contact:
Lark Books
67 Broadway
Asheville, NC 28801
(828) 253-0467

Manufactured in China

ISBN 13: 978-1-60059-580-6

For information about custom editions, special sales, premium and corporate purchases, please
contact Sterling Special Sales Department at 800-805-5489 or specialsales@sterlingpub.com.

Contents

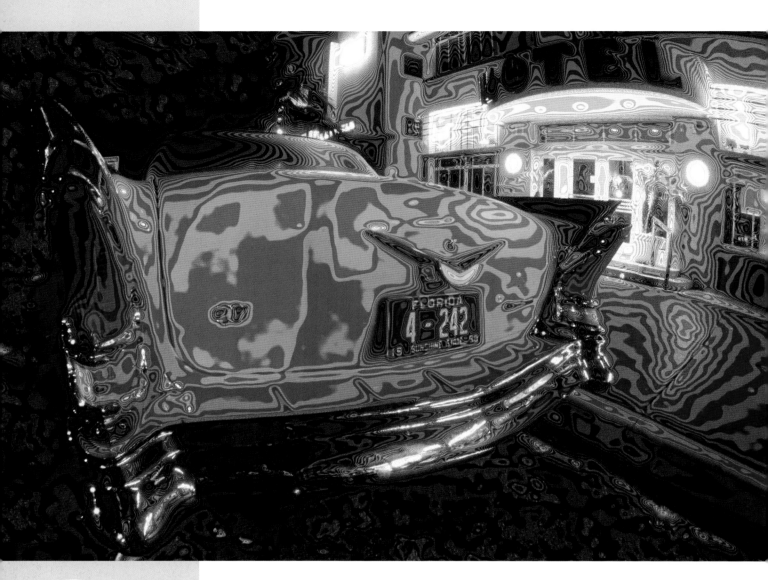

Foreword

Modern digital cameras, especially SLR (single lens reflex) models, represent a remarkable level of technical achievement in which most picture-taking functions have been automated. Yet, despite all of these advances, there are circumstances that still require photographers to apply certain knowledge in order to effectively use the camera's automated options. One important example is the need to understand how the various qualities of natural and artificial light produce very different results in a recorded image; each type of light source will have its own peculiar color characteristics and levels of contrast. These, in turn, influence everything from how colors are reproduced to the overall mood of the scene. A well-informed photographer will also realize that the human visual system is constantly accommodating to such differences, while the camera only records what is there.

In addition to being sensitive to the physical characteristics of light sources and the limitations of human perception, we photographers will also frequently want to alter the way some visual aspect of a subject or a scene is rendered. For example, in the portrait studio, eliminating skin imperfections and blemishes is likely to be well received by the client. On the other hand, a landscape photographer usually wants tack sharp pictures while looking for ways to separate out various picture elements, such as white clouds against a blue sky. And then there is the constant struggle among all photographers to maximize dynamic range, capturing detail in both deep shadow and bright highlight areas.

One of the most effective tools a photographer has for dealing with all these variables is the use of camera filters and specialized filter software. Historically, camera filters came into widespread use to correct color disparities between light and film. Common examples include color conversion, color compensating, and light balancing filters for the correction and fine-tuning of color. Many of the tasks once achieved by these filters can now be handled by selecting the appropriate white balance setting in your digital camera, or rendering your images using image processing software.

Soft focus camera filters have an even longer history, extending back to the era when black-and-white films were the dominant recording medium. Soft focus filters have many uses, depending on the goals of the photographer. For example, they are used to "cleanse"

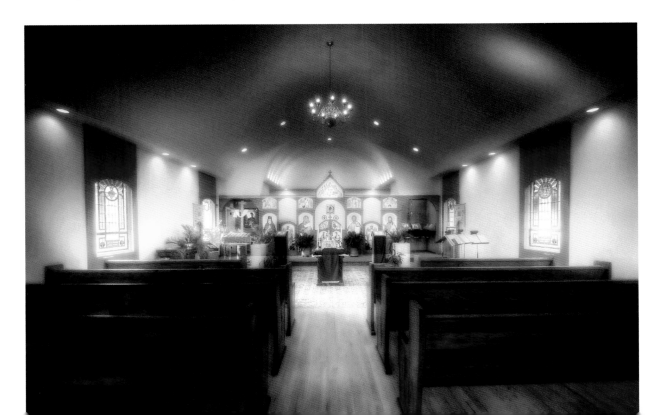

And then there are camera filters that are used by both color and black-and-white photographers, such as the polarizer and neutral density filters. These two filters have the ability to provide something that cannot be replicated with software. The polarizer is able to remove glare reflections, while the neutral density filter will block enough light so that a very slow shutter speed can be used for various blur motion affects.

Besides the use of filters for corrective applications, photographers have always embraced filters for their creative potential. Using filters creatively allows us to refine and extend the impact of an image as a whole or to isolate certain image elements. Photographers' unique filtering choices are guided by their own style and desire to interpret a subject, such as combining a diffusion filter with a warming filter to establish or reinforce a specific mood. Filters can even add something to the scene that was not there originally. Graduated color filters, for example, used on the camera or added later with software, are extremely effective at converting a dreary sky into an area that adds strength and chromatic expression to the composition. Introducing a fog-like atmosphere, enhancing a specific color, or even

subjects of unwanted details, to make the subject look good by mitigating or removing flaws in the surface texture of the face. Other uses included the introduction of mood by diffusing the light to create an atmospheric feeling. Stronger soft filters can also be used to soften details in a picture to the point where only larger structures are recognizable, such as eliminating distracting wall textures in a photograph of a building so that the dominant shapes come through more strongly.

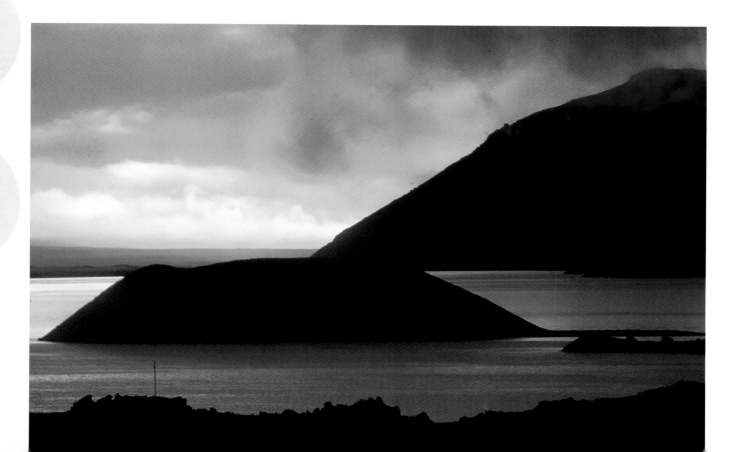

placing a small star burst within a candle flame can all play a role in the photographer's interpretation of a subject or a scene. Filters, whether optical or digital, make these interpretations possible. This creative role is one of the most exciting aspects of filtration; it relies on the photographer's willingness to try something different and is limited only by his or her preferences and creativity.

Using filter techniques inevitably extends the power of the photographer to express a more personal view of the world. Much of this has been made possible in recent years by the growth of digital photography and the development of specialized software filter programs. Controls contained in such programs as Nik Color Efex Pro, Tiffen Dfx, and Pixel Genius Photokit provide an almost unlimited number of ways to give an image that personal touch. In addition, the white balance tool built into digital cameras can be used to control the color characteristics of light during image capture, essentially acting as a set of built-in electronic filters.

Today's photographer is faced with what can sometimes seem like an overwhelming number of choices when it comes to filtration. In fact, any attempt to review every possible filter effect available in today's market would require multiple volumes and would almost assuredly be out-of-date before it hit the shelves. That said, the main goal of this book is to present you with an overview of optical and software filtration effects that can be used to compliment your digital workflow. The range of corrective and creative effects covered here is aimed to be representative, but is certainly not exhaustive. In short, this is a book by a photographer for photographers that explores how different types of filtration can deliver an enormous range of image effects. My goal is to present enough key information so that you can envision some feasible applications for your own work. The examples I have included here are meant only as starting points from which I hope you can envision other possibilities.

All light is not the same—for that matter, neither are photographers—and that gives us all the chance to create something different each time we pick up our cameras.

The Photographic Qualities of Light

INTRODUCTION
INTRODUCTION

THE FORMATION OF A PHOTOGRAPHIC IMAGE is based primarily on recording light particles reflected off the surfaces in a scene. As light travels from its source, is reflected, and enters the camera, many of its basic qualities can change. This is a result of the interaction of the light with the physical properties of different surfaces, as well as with the atmosphere. It is, therefore, not unusual to see the color content of the light shift, the contrast alter, and the intensity diminish. In addition, various light sources have significantly different physical characteristics to begin with. All these factors will have an impact on the appearance of a scene, accounting for why the same subject can look so different under various lighting conditions.

Historically, photographers have relied on optical filters and gel lighting filters to deal with the many changes that can occur before light reaches the camera. Filters have also been used beyond this corrective role to explore different creative interpretations of a subject. With the advent of digital photography, this dual role of corrective control and creative possibilities that filters have traditionally played has been greatly expanded. In some cases, digital technology has all but replaced the role of camera filters, such as in the case of in-camera white balance control, which is the electronic equivalent of using certain light balancing and conversion filters. Still, many digital photographers routinely use a number of optical filters. Knowing which camera filter, what camera control, or what software filter to choose is based on a working knowledge of the key characteristics of light and how it can be changed by the physical environment.

The purpose of this chapter is to present key information about the characteristics of light and its behavior as a basis for understanding how the process of filtration works in photography. Fortunately, this information does not have to be understood on the level of a college physics course. On the contrary, it comes down to knowing just a few basic principles, as well as how and when to apply them.

The easiest way to approach the relationship between light, the environment, and the process of filtration is to think in terms of three photographic qualities of light: intensity, contrast, and color content. Each of these qualities, individually or in combination, will influence your choice of filters and digital camera settings when taking a picture, as well as which software tools and techniques you choose when you work on your images in the computer. Most filters, in fact, are categorized by how they alter one or more of these three photographic qualities of light. So, let's look at these properties while introducing some of the most common filter applications. We will also briefly explore how humans perceive light and how this affects the picture-taking process.

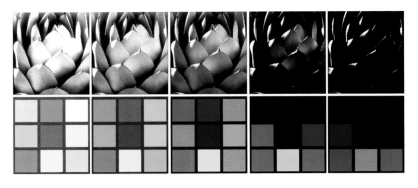

LIGHT INTENSITY

LIGHT INTENSITY

PHOTOGRAPHERS VIEW EACH SCENE in terms of tonal values of brightness, from the darkest shadows to the brightest highlights, recorded with discernable details. In between these darkest and lightest areas are the middle tonal values that record much of the key information about the subject's color, shape, and texture. The most basic requirement for a photograph is to have enough light to fully record the highlights, shadows, and midtones. Without sufficient light, key information about the physical makeup of the subject will progressively descend into darker and darker renderings; too much light in the scene will "blow out" highlight areas, causing loss of detail in the brightest parts of the scene (see the image set above for examples of each of these circumstances).

Digital cameras base their exposure on an internal metering system that is controlled by the camera's computer and designed to measure the intensity of the reflected light. The meter's response is linked to the ISO sensitivity setting. The base ISO sensitivity of the camera sensor is fixed, and is represented by the lowest ISO number available for selection (though sometimes lower ISO settings are selectable). Increasing the ISO sensitivity setting instructs the camera's computer to amplify the signal beyond its base sensitivity. Thus, the higher the ISO number, the greater the amplification. A typical

⬆ If you don't record enough light with your exposure, details become lost, colors lose their chromatic values and, eventually, your subject may no longer be recognizable. Conversely, too much light will render highlights without details and shift colors to appear more washed out and pastel-like.

range of settings would be ISO 100 to ISO 1600, with even higher and lower settings found in more advanced cameras.

As ISO settings double, the camera acts twice as sensitive to light. This is equivalent to decreasing the shutter speed by one half or opening up the lens by one stop (i.e., going from 1/60 second to 1/30 second, or from f/11 to f/8, as summarized in Table 1, below). Changing ISO settings allows you to adjust the sensitivity from one exposure to the next in response to changes in light intensity. This ability to make ISO changes anytime across a range of sensitivities is one of the many advantages digital capture has over film, but increasing ISO does come with a tradeoff: an increase in the appearance of non-image forming artifacts called noise. Later in this book, we will discuss how best to filter the effects of noise using software (see pages 141–146).

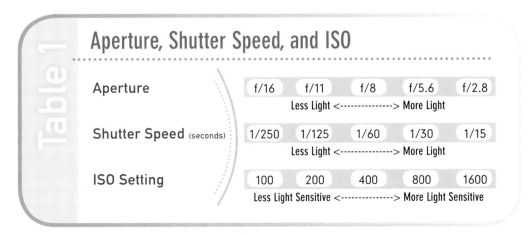

Aperture, Shutter Speed, and ISO

Table 1

Aperture	f/16	f/11	f/8	f/5.6	f/2.8
	Less Light <-------------> More Light				
Shutter Speed (seconds)	1/250	1/125	1/60	1/30	1/15
	Less Light <-------------> More Light				
ISO Setting	100	200	400	800	1600
	Less Light Sensitive <-------------> More Light Sensitive				

Note: Each doubling of the ISO setting produces the equivalent of opening the aperture by one stop or reducing the shutter speed by half.

Reducing Light Intensity

Neutral density filters are ideal for reducing the intensity of light in a scene (or a portion of a scene), and they come in a variety of forms. Their purpose is to block some of the light without changing the color content of the light. For example, a neutral density filter with a uniform layer of neutral gray material can be used to reduce the high intensity light typical of a sunny day. This would allow for the use of a shutter speed slower than what would be possible using the smallest aperture and lowest ISO setting on the camera while still maintaining accurate exposure. For example, you might use a uniform neutral density filter to have access to a shutter speed slow enough to turn moving water into a blur on a sunny day. We will learn more about neutral density filters later on in this book (see pages 52–54).

Software filters can also raise or lower the recorded brightness of a whole scene or selected areas in a scene. This, however, is different from using a neutral density optical filter to get access to slower shutter speeds. Neutral density filters, therefore, give the photographer important means to create unique effects at the time the picture is taken—a noteworthy benefit to this type of optical filtration.

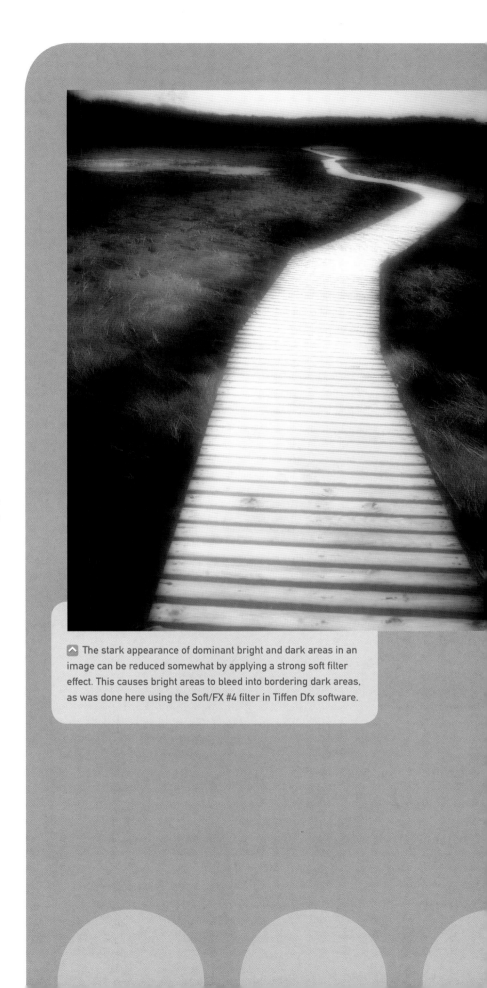

The stark appearance of dominant bright and dark areas in an image can be reduced somewhat by applying a strong soft filter effect. This causes bright areas to bleed into bordering dark areas, as was done here using the Soft/FX #4 filter in Tiffen Dfx software.

LIGHT CONTRAST
LIGHT CONTRAST

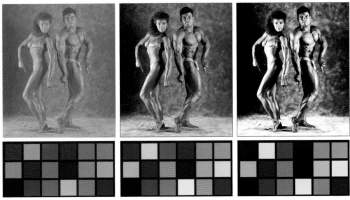

AS A VISUAL CONCEPT, CONTRAST can be described simply as the degree to which individual colors, or shades of gray in a black-and-white image, appear separate and distinct from one another. Take for example, a situation in which the subject is a woman in a white dress, wearing a large brimmed hat and holding a standard color chart. Direct sunlight produces a high contrast situation in which the details of her face will be lost in dark shadows, and details such as lace trim on the dress will be overexposed. Also, the lighter colors on the color chart may appear "washed out." This is because the contrast has exceeded the sensor's recording latitude. On the other hand, when photographing a subject in the light of a hazy sunny day, a bright overcast day, or an open shade area, these lighting conditions are typically rated has having a medium to a medium-low level of contrast. Under this light, the woman's face will be in a lighter shadow, with her features quite distinct along with the details of the dress. The color chart will also display a full range of tones. If you were shooting under a heavy overcast light, however, the contrast level would be so low that the colors turn dull and "muddy," with no distinct highlight

⬆ Notice in the high-contrast versions of the image and color chart (above), the deep shadows and the brightest highlights lack details, while colors have lost some of their chromatic value because the range of contrast exceeds the sensor's recording latitude. Conversely, in the very low contrast versions (left), there really are no definable highlights or shadows and the colors look dull. Moderate contrast levels (middle) display detail in important highlight and shadow areas as well as a full range of distinct tones.

or shadow areas. These differences in contrast are demonstrated in the example of the bodybuilders and the color chart, above.

There are also situations where brightness values from either the dark end or the light end of the brightness scale dominate a picture. In such cases, traditionally referred to as low-key and high-key, respectively, the main elements in the picture are still recorded in detail, as seen in the examples below.

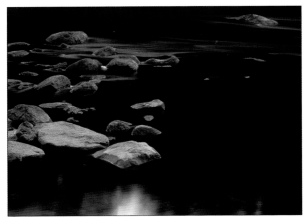

⬆ In the low-key images of the rocks and water (left), there is an absence of significant midtone and highlight values, while the shadow areas are recorded with good detail. In the high-key snow scene (right), there are no significant middle or shadow values, but there are details in the snow. In both cases, a proper exposure is critical to producing enough separation of the values in the main areas of the scene.

Local Contrast

Usually, contrast is based on a general impression of the whole picture, often referred to as global contrast, but there is also local contrast to consider. Local contrast typically refers to the difference between colors or gray tones that border each other. Certain optical filters are very effective at increasing local contrast, such as in the case of filters made to increase the intensity of specific colors or sets of related colors. For example, an enhancing or intensifying filter for warm colors can boost the reds and oranges of autumn foliage while not significantly changing the color of green pine trees or grass. On an overcast day with the light producing a low-contrast rendering of the colors in a scene, I have found an enhancing filter, such as the Tiffen Enhancing filter #1, will selectively raise the warm color intensity, as seen in the example at right. Another example is when a polarizing filter is used to darken clear blue skies while leaving the rest of the scene unaffected, as in the picture of the United States Capital building below. Both of these are typical examples of using optical filters to increase the local contrast. (See the section on Time-of-Shooting vs. Software Contrast Control on page 26 for information on why choosing an optical filter may present an advantage in some of these shooting situations.)

(Before)

(After)

Notice in the "after" picture, taken with the Tiffen Enhancing filter #1 (bottom), the red autumn leaves on the grass stand out much more than in the "before" picture, taken without a filter (top). Also note that the warming filter does its job without significantly altering the green color of the grass.

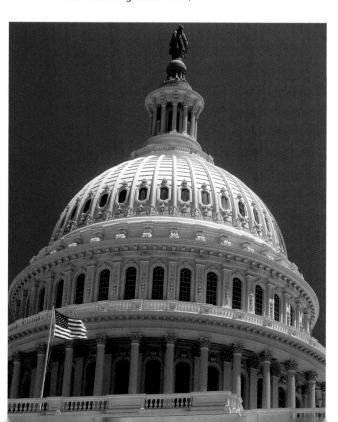

Using a polarizer filter can deepen the blue color of a clear sky without introducing a colorcast or a shift in colors. This can be seen in the neutral white sunlight roof areas of the Capital building and the colors in the flag. (For more information about polarizing filters, see pages 48–51.)

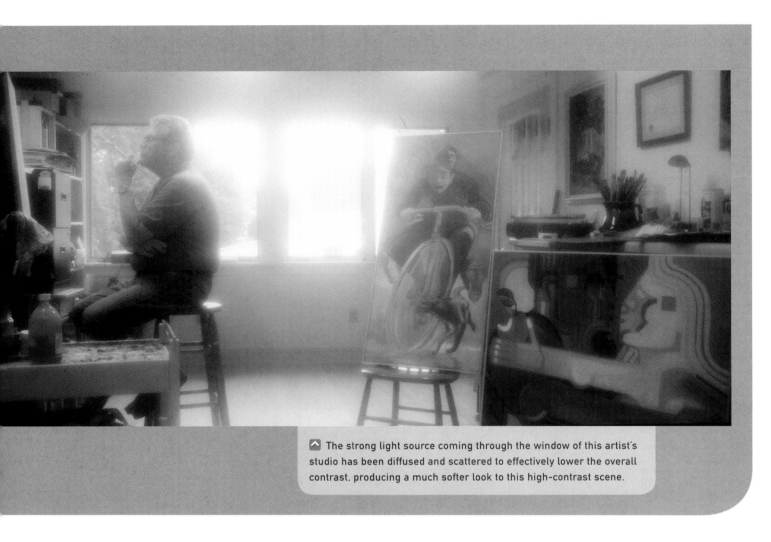

The strong light source coming through the window of this artist's studio has been diffused and scattered to effectively lower the overall contrast, producing a much softer look to this high-contrast scene.

Reducing Global Contrast

Reduction in global contrast is a characteristic of many of the stronger soft focus, diffusion, and fog or mist filters because they tend to scatter the reflected light coming off of surfaces in the scene. Bright areas are thus reduced in intensity in the captured image while the scattered light bleeds into midtone and darker areas, causing them to become lighter, as seen in the example above. These filters can also tame bright spots to some degree by spreading out pinpoint light reflections, as illustrated in the lower right corner of the pond scene, at the bottom right of the opposite page.

Some of the stronger diffusion and soft focus filters can also produce a glow or halo effect that can impart an ethereal look, as seen in the example xxx. Finally, there are specialized "low-con" (low-contrast) filters that are specifically designed to reduce contrast without causing a pronounced soft look. We will examine the use of these optical soft filters with digital cameras in more detail on pages 58–63.

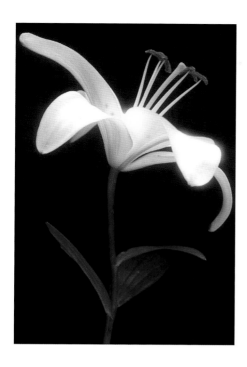
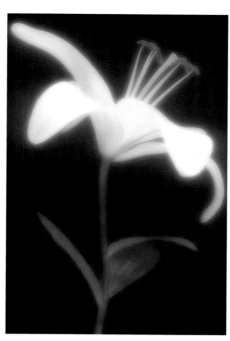

Strong soft-effect filters are sometimes classified as glow or halo filters and are capable of spreading light from bright highlight areas in tight patterns. This makes highlights appear to glow, as seen in this before (left) and after (right) flower picture.

A moderate diffusion filter was used on this pond bathed in high contrast sunshine to soften the over all look of the scene. The filter also spread out the pinpoint light of the reflected sun in the water (lower right corner).

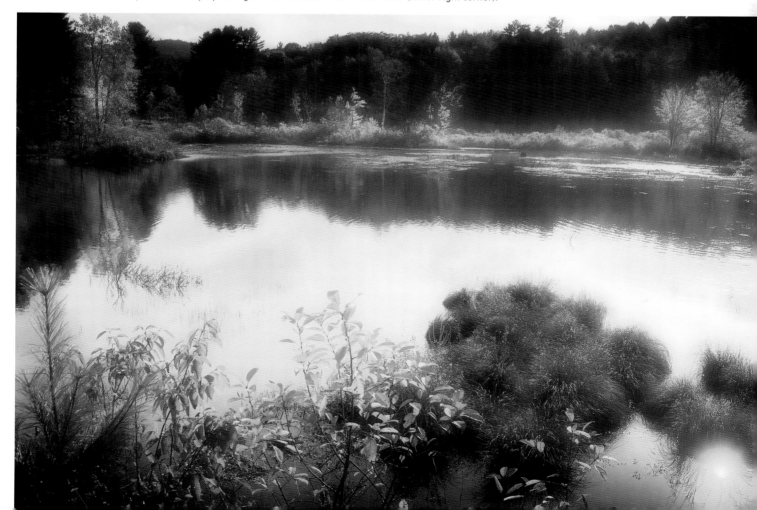

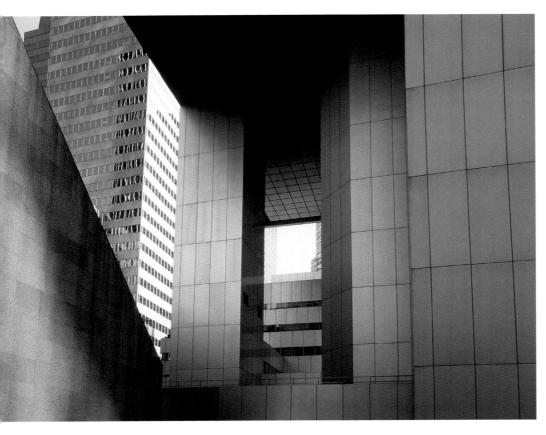

In this photo, you can see that the building in the left top of the frame, which is illuminated by direct sunlight, has a much higher contrast level than the building in the foreground, which is illuminated by indirect, reflected light. This difference in contrast makes sense, as the sun is a small pinpoint of light in the sky, while the indirect illumination of the foreground building is from a large panel of reflected light from surrounding surfaces.

In the frames below, direct sunlight (top) versus diffused light through a cloud (bottom) has a markedly different effect on the subject matter.

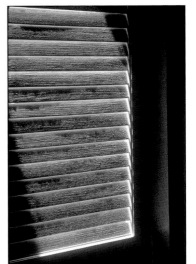

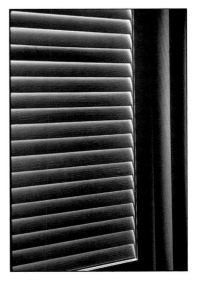

How Does Light Effect Contrast?

General levels of contrast are controlled to a large degree by the size of a light source relative to the size of the subject. As a general rule, the smaller the light source, the higher the level of contrast. As an illustration of this principle, look at the picture of the louvered door illuminated from behind by direct sunlight in the top frame of the example at right. Compare that to the bottom frame, taken shortly after a cloud moved in front of the sun. In the direct sunlight picture, the sun is basically a small spotlight in the sky, hitting the door slats with a very narrow angle of light. This causes strong shadow areas to form, as well as putting concentrated light on highlight areas. On the other hand, the light coming through the cloud has a much broader field of coverage, illuminating the surface areas much more evenly and filling in potential shadow areas.

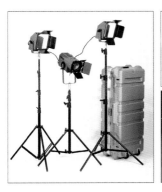

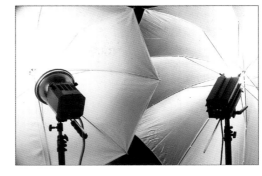

Figure 1

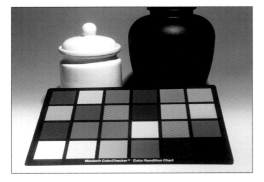
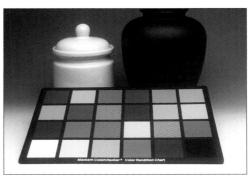

These same contrast conditions can be duplicated in the studio using light modifiers. Typically, a small light source, such as the halogen lights and strobe heads seen in the top left frame of Figure 1 (above), will produce a high contrast rendering, as seen in the bottom left frame. When these light sources are used with an umbrella, as in the top right frame of Figure 1, the result is a moderation of contrast, as seen in the bottom right frame where this larger light source created a more even coverage. By bouncing the light into the umbrella, this source was effectively made larger and more even in coverage. Studio photographers also use soft boxes to add diffusion to the enlarging effect of reflections bouncing off the sides of the box (Figure 2, right). This combination of reflection and diffusion is a form of light filtering that mimics the diffused light from clouds and the reflected light from the sky.

Figure 2

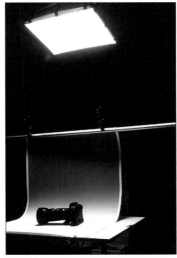
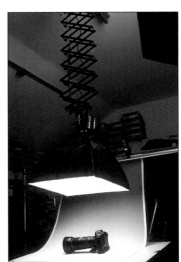

In the images on the left top and bottom, the soft box is so far from the subject that it is serving as a small light source, producing dark shadows and overexposed highlights. Moving the box close to the subject, as illustrated in the top and bottom photos on the right, turns the soft box into a large light source, and the reflected and diffused light from it produce lighting conditions with much lower contrast.

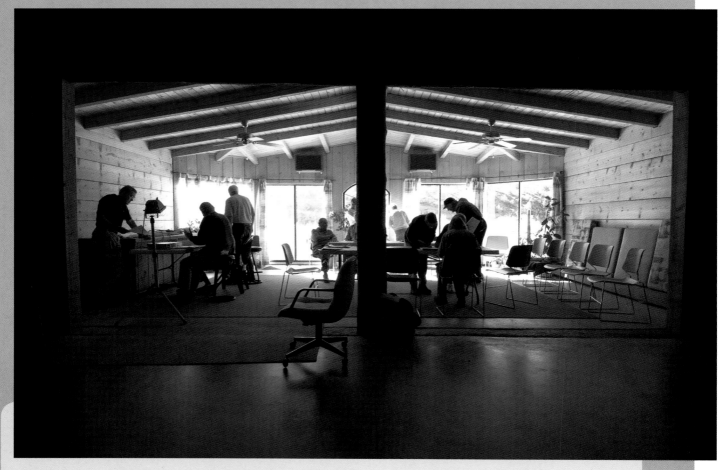

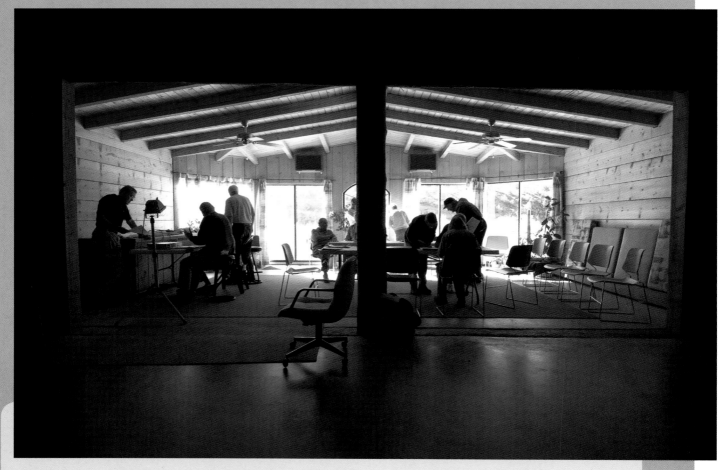 Extreme contrast situations have often forced photographers to either set the exposure to capture the brightest areas and midtones with details, causing the shadows go black, or, as is the case here, to change the exposure to capture as much detail as possible in the shadows and midtones while overexposing the highlight areas. Now, with modern advances in digital imaging, photographers can also elect to create HDR, or high dynamic range images. For a thorough look at this exciting photographic technique, check out Ferrell McCollough's book *Complete Guide to High Dynamic Range Digital Photography* (a Lark Photography Books publication).

Often, a scene will contain mixtures of contrast because of different lighting conditions. For example, when photographing a city street on a sunny day, the tall buildings would be in the high contrast light of direct sunshine while lower subject matter is lit by indirect light, resulting in much lower contrast. This is the case in the example on page 20, where moderate- to low-contrast, indirect, reflected light dominates the foreground, allowing details to be recorded while the side of the tall building facing the sun is slightly overexposed. Again, this is due to the size of the light sources.

In many cases, the problem in situations like this is that the dynamic range of the scene exceeds the camera's ability to capture the brightest highlights and deepest shadows with enough detail. For example, a scene may have a dynamic range of 11 stops but the sensor can only handle a dynamic range of six or seven stops. A typical example of this occurs when trying to photograph an indoor scene where direct sunlight enters the room, as seen in the example above. In this case, the dynamic range may be as much as a difference of 13 stops between the scene outside the windows and the deepest shadows to be recorded in the room.

Filters for Controlling Contrast

One of the most useful optical filters for dealing with high contrast scenes typical of landscape settings is the graduated neutral density filter. Unlike uniform ND filters (discussed on pages 53–54), this design has light absorbing gray neutral density material spread over only one half of the filter's surface. It is especially effective at lowering the brightness of sky areas so that any clouds present can be recorded with details when the camera is set to correctly record the rest of the scene, as seen in the example below. Without this reduction in the brightness of the sky, the dynamic range would exceed the latitude of the sensor.

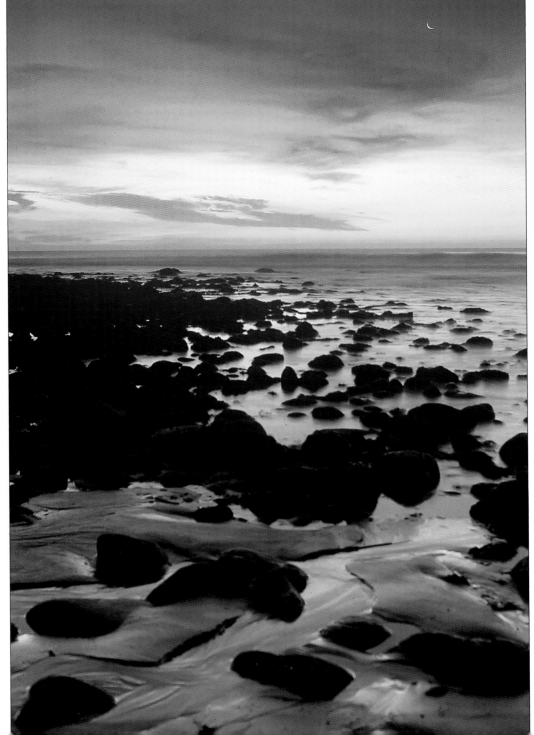

◀ A graduated neutral density filter helped to hold back some of the bright sunset light in the sky and the horizon in both of these images. I then set the exposure to properly render the weaker light in the middle ground and foreground areas. I used a one-stop neutral density filter in the seascape, while the desert sky required holding back two stops of light. Even with this strong filtration, some areas of sky were still overexposed in both pictures.

In recent years, special HDR (high dynamic range) software programs have become very popular for their ability to deal with high contrast scenes. Photomatix by HDRsoft, Dynamic Photo HDR (DPHDR) by Mediachance, and LR/Enfuse, are three popular examples of these programs. The usual procedure is to take a series of pictures at different exposure levels, as illustrated in the example below. The exact number of exposures needed depends on the dynamic range of the scene. The software then combines all exposures so that a wide range of contrast has been recorded. Needless to say, this has to be done with a scene in which the major subject matter is not moving, as the exposures must fall into exact registration with one another. In a very real sense, HDR programs filter out levels of excessive contrast while combining the recorded details into one final image.

⌄ In this HDR photo (bottom), I made four exposures approximately one stop apart, as seen in the top four frames. I used Photomatix HDR software to combine the four exposures and display the full contrast range of the scene.

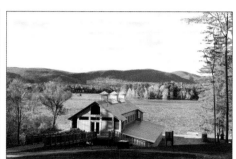
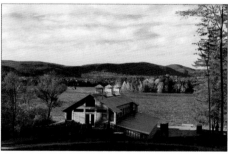
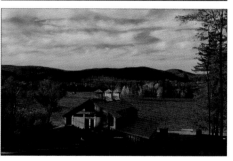

Time-of-Shooting vs. Software Contrast Control

The ability to control contrast on both a global and a local level is a common feature of many software programs. Curves, Contrast, and Levels (or similarly named functions) are some of the more readily available software tools used for contrast control. Many programs also have a Saturation tool that can increase or decrease the chromatic contrast between selected colors for a more localized effect. More advanced tools, including the use of different "painting" and brush techniques, as well as sophisticated ways of isolating areas in conjunction with layers for both global and local changes, are also available. Some of the specialized filter programs covered later in this book offer automated filter effects that use these kinds of advanced methods. This is one of the attractions of software filters—the use of automated, advanced techniques without the need to learn complicated step-by-step procedures.

While software can be used to achieve many of the effects once accomplished by optical filters, it is important to understand when and why to use an on-camera optical filter or an in-camera filter setting rather than depending on a software solution. In addition, there are times when using both camera and software filtration methods work very well for a particular image. The key here is to remember that camera optical and electronic filters deal with the raw light of a scene, while the computer can only deal with recorded light. Optical filters in particular alter the light before it enters the camera, and that may represent a decided advantage. For example, a polarizing filter can remove glare reflections that have overexposed an area in a scene, while a graduated neutral density filter can lower the brightness of a sky area to prevent clouds from looking "washed out." On the other hand, the power of software programs to quickly and accurately adjust Kelvin temperature (white balance) and contrast certainly simplifies things. So, the bottom line here is that, to be a knowledgeable photographer, you need to make an effort to understand the variety of filtration choices that exist and when you might opt for one method over another, or combine several methods to create your ideal vision of the photograph. That is what this book is all about: explaining the important, and often critical, choices in image filtration.

COLOR CONTENT OF LIGHT
COLOR CONTENT OF LIGHT

THE THIRD AND MOST COMPLEX QUALITY OF LIGHT is color content. In order to better understand this quality and how it can be affected by filtration, lets start by covering a few basic principles of color theory. Light sources typically used in photography, such as natural light, electronic flash, and studio rated tungsten sources, are composed of three basic wavelengths. These wavelengths are perceived by humans as the colors red, green, and blue—often referred to as the acronym RGB. When all three RGB wavelengths are present in equal proportions, the result is colorless white light, called neutral light, as illustrated in Figure 3, below.

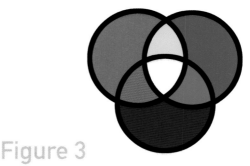

Figure 3

⌃ Most light sources used in photography are made up of three basic wavelengths of light—red, green, and blue (RGB). When these three are combined in equal amounts, as seen here in the overlapping circle area, the result is a neutral, or colorless, white light.

🔽 Tungsten bulbs characteristically produce a warming effect, as seen in this picture taken with the white balance set for recording daylight; the natural light coming through the doorway is, therefore, recorded as neutral. To record the interior illuminated by the overhead lighting as neutral in color, the white balance would have to be set to tungsten, which would then give a cool blue colorcast to the natural light coming through the doorway. Remember that white balance is a global setting, so the entire scene is affected.

🔼 Clouds and shade are conditions in which blue wavelengths of light are most prominent. Consequently, this light lends a cooler look to images if the camera is set to daylight white balance, as seen in this example. If the camera's white balance were set to cloudy, the scene would have been rendered without the strong blue colorcast. Many digital cameras have both cloudy and shade white balance options. The shade white balance option offsets the dominance of cooler wavelengths to a slightly greater degree than the cloudy setting, as shade has slightly cooler light than open sky with cloud cover.

If neutral white light were to strike a pure white wall and be recorded by a camera balanced for white light, the result would be a pure white rendering. If the proportions of RGB wavelengths in the light were not equal, then the white wall would take on a colorcast determined by which wavelengths were present in a higher proportion. Most commonly, this change in proportions occurs between the red and blue wavelengths, with green remaining relatively constant. If the source has proportionally more red than blue, then a camera with the white balance set to record white light (either the daylight or electronic flash white balance settings) will record a white wall with a warm colorcast. For example, household tungsten bulbs have a much greater proportion of warm wavelengths, as seen in the example above, right. Conversely, if blue wavelengths are in a greater proportion, the image will have a cool cast typical of a shade setting or the conditions on an overcast day, as seen in the example above, left. Thus, photographers will frequently describe light as being warm, cool, or neutral. As we will see when we review information about the Kelvin scale (on pages 30–31), the differences in the proportions of red and blue wavelengths can be represented by a numerical value.

The amount of green wavelengths in light sources used in photography will tend to remain at about 30%. Commercial overhead fluorescent tubes, however—commonly found in offices, schools, trains, etc.—have

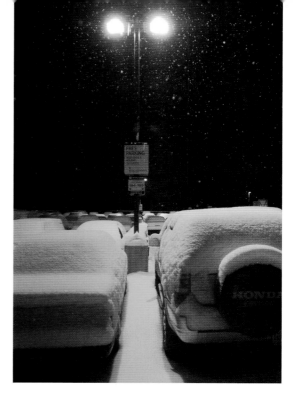

a green spike and will therefore render our theoretical white wall with a green cast. The example below shows the interior of a commuter train with such lighting. Furthermore, some light sources have discontinuous spectrum lighting. That is, the lights do not have a full RGB spectrum, or some wavelengths are only present in very small amounts. Outdoor mercury and sodium vapor lights are two common examples of this, as seen in the examples at right and at the top of the opposite page..

Different proportions of the RGB wavelengths combine together to form all other colors in RGB light, which is why these three wavelengths are designated the "additive primaries" of light. Human vision is capable of seeing all the color combinations between 400 and 700 nanometers. This range is called the visible light spectrum, illustrated in Figure 4, on the opposite page.

⌃ As you can see here, sodium vapor light sources have very little blue or green wavelengths, hence the predominance of red in this parking lot snow scene. Again, this is a case where you may elect to use your camera's custom white balance option if you have one. Unusual lighting, such as that shown here, may also require the use of software to obtain a reasonable rendering of colors.

☑ Fluorescent bulbs typically produce a greenish colorcast in photographic images, as seen here in this image recorded with the camera's white balance set to record daylight. As photographers, it is important to be aware of the fact that the human brain is continually adjusting to the colors around us, and colorcasts may not be recognized by our eyes. (See pages 37–39 for more about how we perceive light.) The camera, however, responds to color in a very specific way, depending on the selected white balance setting. In this case, setting the camera's white balance to fluorescent instead of daylight would have greatly reduced the green colorcast.

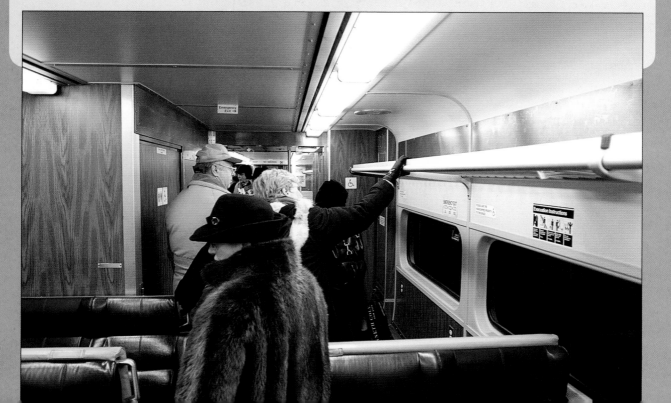

colorcast will darken the appearance of other colors, reducing their visibility, such as would occur in a night scene. If your photographic goal is to accurately record colored and neutral areas, however, then a colorcast is to be avoided, such as when trying to capture a colorful room that also contains neutral surfaces, like a white wall or white tablecloth. Another important and common example is the rendering of skin tones and hair color in a portrait. In particular, portrait photographers are very concerned with accurately recording skin tones.

So where do colorcasts come from? We have already noted the two main causes: an imbalance between the Kelvin temperature of the light versus the white balance setting of the camera, and the effect of colored surfaces on the proportions of colors in a light source as it is reflected. A third cause of colorcasts that is sometimes overlooked is the shift in the chromatic (color) content of the light when it passes through a colored surface. For example, window light filtered through sheer, light blue curtains will produce a weak blue cast on a bride's white dress. Studio photographers know that the face fabric on a soft box can yellow over time, causing a slightly warm colorcast. Once again, the principle of subtractive filtration is at work; the weak blue of the curtain or the traces of yellow in the soft box fabric will shift the proportions of RGB wavelengths. This is also how a colored camera filter is able to change the color content of the light entering the lens. The stronger the filter's color, the more complete the absorption of all colors other than that of the filter. (See page 36 for more details on color filtration for black-and-white photography.)

Photographers shooting window light portraits will usually avoid high-contrast direct sunlight, instead opting to use the more pleasing moderate contrast of indirect sunlight—typically, sunlight reflected from the sky and the areas outside the window. So, while you may think that shooting in window light means shooting in neutral sunlight, the color content can, in fact, contain a colorcast when the indirect sunlight reflects from different colored surfaces, either inside the room or outside the window, as seen in the example at right.

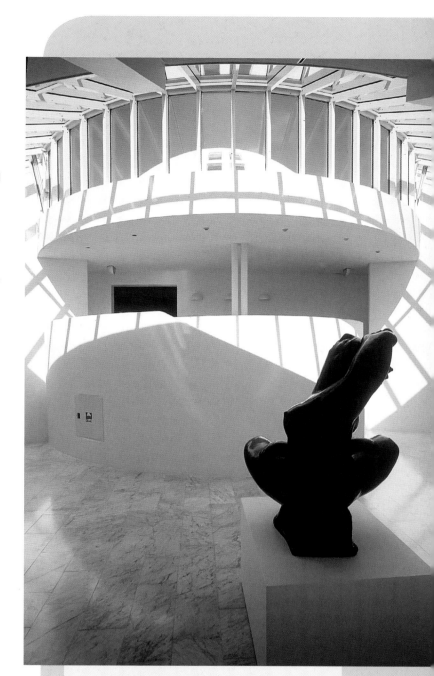

⌃ In this museum setting, direct sunlight is entering a museum with a green marble floor. While the direct sunlight is color neutral, the presence of large, green-colored reflective surfaces combined with the weak light in the shadows produce areas with a slight green colorcast. The light reflecting off of the green floor has had its neutral RGB proportions shifted, with the green wavelengths of light becoming more evident. It is this reflected light that illuminates the shadow areas that are not in direct sunlight. Where the direct sunlight is hitting the white walls, they are recorded without the weak colorcast.

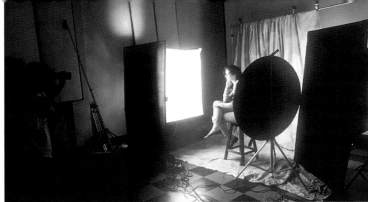

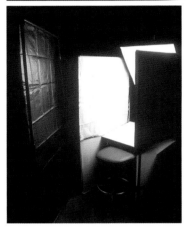
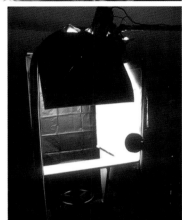

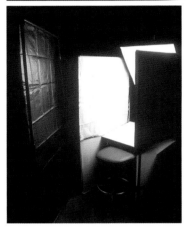 Large black gobo panels are used by studio photographers to isolate a subject from stray reflected light and the colorcasts such light can produce in weak shadow areas. In the top picture, panels have been used to help keep the light from a large soft box from reflecting back from colored walls onto the subject. In the bottom frames, a shooting booth built with gobo panels completely isolates a subject for head and shoulder portraits.

When colorcasts form after light comes into contact with a colored surface, photographers will often say that that the light has "picked up a color" when, in fact, the opposite is true; the colorcast is caused by a shift in the proportions of RGB wavelengths due to the color subtraction principle. Some wavelengths of light were absorbed, thus increasing the proportions of the other wavelengths. There are many mechanisms at work in the natural environment that can produce noticeable shifts in color, some of which I have illustrated in the portfolio section at the end of the book (see pages 150–152). Studio photographers are able to control the intrusion of a colorcast by either not having large colored surfaces in the studio in the first place, or by blocking the contaminating light with large black panels called "gobos," typically positioned around the subject, as seen in the example above.

Photographers who have to work on location, such as wedding and event photographers, usually cannot employ controls such as large gobos. Often, these photographers will use flash directed at the main subjects, balanced to the intensity of the available light, while having the camera set to the flash or daylight white balance setting. Another trick in an office setting is to fire the flash into the overhead fluorescent lights, creating a higher illumination level and washing out some, if not all, of the green cast typical of this kind of lighting. If a colorcast cannot be eliminated or controlled on the spot, then corrections will have to be made in the computer. However, as with most corrective applications, the photographer has to first recognize a situation in which color contamination might occur and, if at all possible, try to avoid it in the first place.

The rule of thumb here is that it is always to the photographer's advantage to try and capture light at the color level appropriate for the final image. This means you have the most complete data to begin with. Otherwise, you will have to work with a file that has color renderings and/or colorcasts that you don't want. Working with RAW files or using the powerful tools in programs such as Photoshop can offer great advantages, but if you don't get the maximum quality that you can out of the light first, you will be working with less color data. The bottom line is, "I'll fix it later in Photoshop" reflects a failure to capture the best possible image that you and your camera are capable of, and that means more time in front of the computer.

Mixed Lighting

Problems associated with mixed lighting represent perhaps the greatest challenge to any photographer when it comes to controlling color. Such common settings as a room with both tungsten and fluorescent lighting, or an artificially lit room where natural light shines through a window, present significant challenges. In the interior shot of New York's Grand Central Station in the example below, I had my white balance set for daylight capture since the light coming through the huge windows dominated much of the picture. The remaining interior lights (mostly tungsten) produced a definite warm color shift in their respective areas. In general, when faced with mixed lighting, you should set your camera's white balance to respond to the dominant light source. In this example, the viewer will probably accept the warm look on the floor of the station, in part because the main light coming through the widow is neutral.

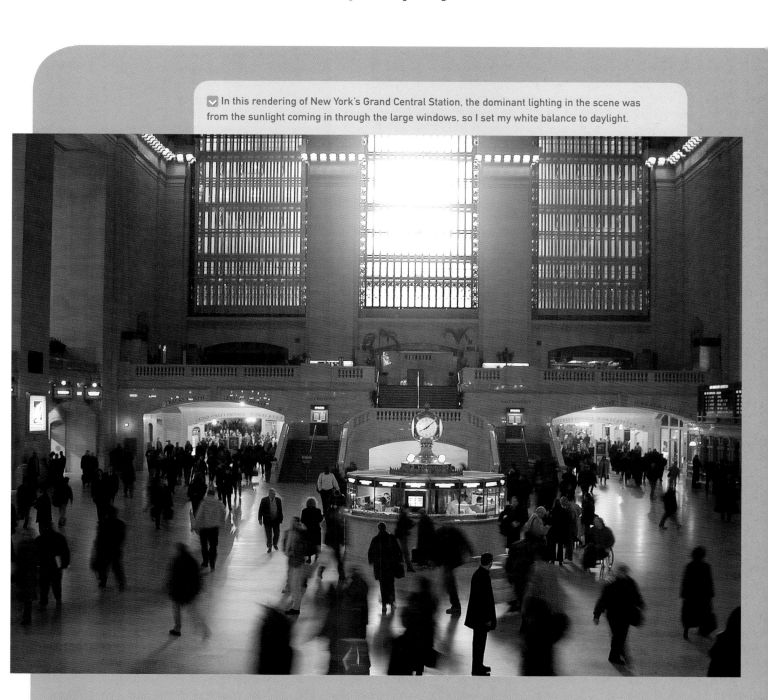

☑ In this rendering of New York's Grand Central Station, the dominant lighting in the scene was from the sunlight coming in through the large windows, so I set my white balance to daylight.

GRAYSCALE AND COLOR FILTRATION
GRAYSCALE AND COLOR FILTRATION

GRAYSCALE—the subtle gradation of gray tones on a scale from pure white to pure black—forms the basis of black-and-white photography. Since white reflects all light and black absorbs all light, the gray tones representing all the colors in a given scene will fall in between these two absolute values. The shade of gray into which a particular color is translated is based on how much light that color reflects. In Figure 7 (below), I have converted one half of each of the colors of a Macbeth ColorChecker to grayscale to illustrate how color translates to grayscale tonality in a black-and-white photograph.

Filtering in black-and-white photography follows the same principles as filtering for a color scene; colored optical filters, or their electronic in-camera or software equivalents, can be used to absorb all other colors to some degree while allowing the color of the filter to come through. The stronger the color of the filter, the more complete the absorption. This gives the photographer the power to change the relative brightness of the different color tones represented in the grayscale. There are a number of software programs that are particularly effective at color filtration for black-and-white imaging, not to mention the capability of many digital cameras to provide black-and-white color filtration during shooting, or as an in-camera processing option. We will cover these filtering techniques in more detail on pages 112–123.

Figure 7

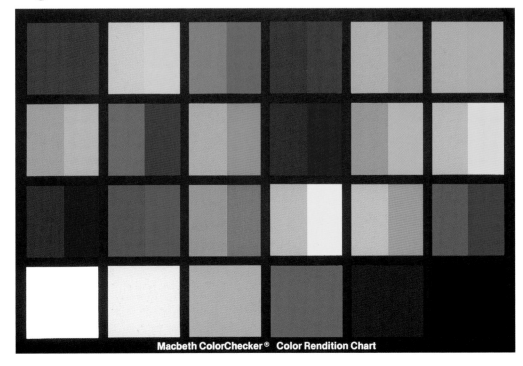

Macbeth ColorChecker® Color Rendition Chart

HOW WE PERCEIVE LIGHT

NO CHAPTER DEALING WITH LIGHT IN PHOTOGRAPHY would be complete without taking into consideration how we humans perceive light. A particular color has a specific physical value on the visible light scale, but our perception of that color is far less exact and can easily be influenced by other colors in the environment, especially if the color content of a light source varies. When photographers use a light meter, handheld or in-camera, they are measuring the intensity of all the wavelengths combined. This gives no information about the color content of the light. If you wish to access that kind of information, there are specialized (and expensive) handheld color meters that will tell you, among other things, the percentage of RGB wavelengths in the light source, as well as the Kelvin temperature and filter recommendations for rendering the colors correctly (Figure 8, below).

In addition to environmental colors and variable light sources, lets not forget our own individual concepts of color when it comes to understanding the factors that come into play to influence our perception of color in a given scene. Each person's concept of color comes from his or her own sensory system and experiences. Unlike the accurate measurements of a color meter, people will differ in their mental perception of color. Just show a series of similar colored swatches to a group of people and ask each to select the "pure" color. The results will surely indicate differing concepts of color in the perceptions of the people. In short, we do not have an absolute concept of color. To test yourself (and without looking at the Macbeth ColorChecker in Figure 6), which of the four shades of red in Figure 9 (below) is the actual red from the Macbeth ColorChecker? The answer can be found at the top of the next page.

Figure 8

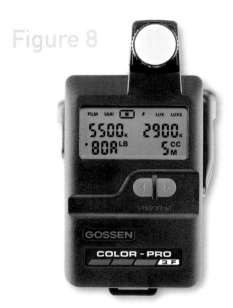

This is an example of a handheld color meter.

Figure 9

Another equally important factor is how insensitive people can be to detecting shifts in color. For example, most people do not pick up subtle colorcasts because our brains are constantly making adjustments for these differences. Only dramatic shifts, like those around sunrise and sunset, are likely to be noticed. When comparing a sunny day to an overcast day, people are likely to observe the lack of brightness as opposed to specific chromatic differences.

People are often surprised to see an unpleasant colorcast in photographs taken under artificial light, such as in the case of fluorescent office lighting. To their eyes, the light appeared neutral when the picture was

 Answer to the Figure 9 riddle on the previous page: The smaller, inner box is the red from the Macbeth ColorChecker standardized color chart.

taken. This is just one example of the way our brain adjusts to and compensates for levels of intensity, color, and even contrast in lighting. As a quick illustration, just look at a paint chart and see the variations in the shades of white. If instead we were presented with just one patch, it would register as pure white until we were shown a slightly whiter patch for comparison. Fortunately, cameras are far more absolute in terms of how they record color and, when dealing with colorcasts, we have very specific, objective tools and ways of measuring color and light that allow us to achieve the look we want for our images.

In general, people will tend to pick up the appearance of a colorcast in neutral white and gray areas before noticing a minor or even a moderate shift in areas of color. (This is something to remember when color-correcting an image in the computer; checking neutral areas for colorcasts is a good starting point.) Undoubtedly, a contributing factor to this is that the pure colors on test charts are not commonly found in the environment. On the contrary, colors in the scenes we view everyday throughout our lives are usually mixtures of colors, with few examples of pure single additive or subtractive primary colors. Most of us do not have an absolute standard for color.

Besides being poor judges of color, human observers will often misinterpret certain visual clues as indicators of high or low contrast. An observer may, for example, interpret the darkening of a blue sky (as typically happens with a polarizing filter) as an increase in the overall contrast of the picture rather than just the stronger separation on a local level between the sky area and whatever is bordering the sky. This false interpretation of contrast, sometimes referred to as

"perceived contrast," should be kept in mind when evaluating the visual effect of a particular camera or software filter. Then, there is the remarkable ability of the eye and brain to adjust quickly to changes in light intensity without really recognizing such differences until they become more extreme.

Finally, if the general viewing audience is poor at detecting shifts in the three characteristics of light (intensity, contrast, and color), you might have guessed that they are pretty much at a loss for knowing how most colors will translate into grayscale. An experienced black-and-white photographer knows that it takes some time to perfect the concept of the black-and-white image in a color-based world. Some photographers will look through a monochromatic filter such as a Zone VI viewing filter, the PEAK Mono-Tone Viewer, or a Tiffen #1 Panchromatic Viewing Filter to get an idea of how colors will translate into black-and-white tones. A more disciplined approach would be to teach yourself to make good approximations on how common colors in typical shooting scenarios will translate into gray tones. (For a course on perfecting the art of seeing in black and white, check out another Lark Photography Books publication: *Digital Masters: B+W Printing*, by George DeWolfe.)

As a photographer gains experience measuring light and recording subjects in different types of light, inevitability there develops an appreciation for the limitations of the human visual system—a system that is constantly making unconscious and automatic accommodations for shifts in color, changes in brightness levels, and differences in contrast. As a knowledgeable photographer, it is always wise to make an effort to know something about the physical

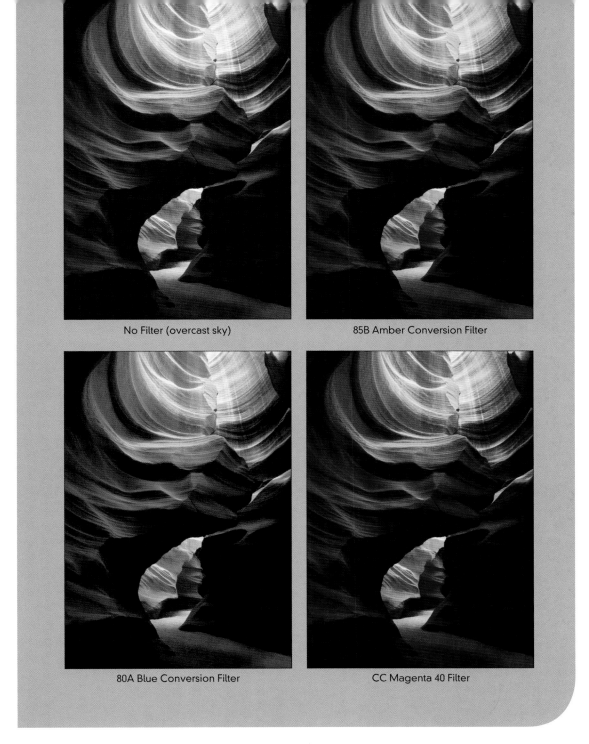

No Filter (overcast sky)

85B Amber Conversion Filter

80A Blue Conversion Filter

CC Magenta 40 Filter

◀ Here are some examples of how conversion and color compensation (CC) filters can alter the appearance of a subject.

characteristics of the light source you are dealing with, the color and reflective nature of the environment's surfaces, and what optical, in-camera, or post-processing software filter options might be employed to either correct a problem or produce a specific creative effect.

The digital era has really given photographers enormous control over light in the captured image—far beyond anything that was possible when working only with optical camera filters. In recent years, camera manufacturers have added to this control by making the RAW file format available. This has opened up a remarkable degree of control over the raw light captured by the camera, from making adjustments in exposure and contrast to swapping out white balance settings post-shoot, among other functions. As we will see in the coming chapters, the software that processes RAW files has taken its place in the software workflow as an enormously powerful tool. All that said, optical filters still have a place in the world of digital photography, and that's the subject of the next chapter.

2 Filters for Digital Photography

The shade or cloudy white balance setting will add additional warmth to a sunset or sunrise, producing a more dramatic rendering.

Enhancing the magenta sky at dawn or dusk by using the fluorescent setting is another creative white balance alternative. Since the people in this image are in black silhouette, only the sky area shows the magenta coloration.

Switching the white balance to tungsten will added a blue effect to this foggy scene.

FILE FORMATS

THE ELECTRONIC DATA that will eventually form the photographic image is organized and saved into a file format (or formats) by the camera's firmware so that computer software can read the data and translate it into an image. The most common camera capture formats are JPEG, TIFF, and RAW. Most cameras allow you to select the level of JPEG compression you want to apply to the recorded file. As you might expect, the lower the degree of compression, the higher the image quality. The advantage here is that the captured files will not take up as much space on the memory card. Also, if you are shooting at high frame-per-second (fps) rates, JPEGs will allow for the highest rate the camera can deliver. On the other hand, JPEG compression does result in the loss of some data in order for the compression to take place, which is why JPEGs are referred to as a "lossy" file type.

Another file format available in some camera models is TIFF. These files have the distinct disadvantage of taking significantly longer for the camera's firmware to process and write to a memory card. This is due, in large part, to the fact that TIFFs use a lossless compression scheme, which produces much larger file sizes than the "lossy" JPEG file data.

The RAW file format has become very popular with professional and serious amateur photographers because it allows for a great deal of correction and reworking of the original data later in the computer with minimal risk of image degradation, if done carefully. Unlike the JPEG and TIFF files that process an image to conform to their respective formats, RAW files contain the original data captured by the sensor in a basically unprocessed form. Thus, by using special RAW file processing software, you can make significant changes in all the qualities of the light, such as changing the Kelvin temperature, adjusting the contrast, filtering out colorcasts, and adjusting the exposure. Once processed, the RAW file must then be saved as a JPEG, TIFF, or proprietary native file type, such as Photoshop's PSD file. The RAW format has greatly extended the ability to make adjustments in the captured light before employing the other creative tools of programs like Adobe Photoshop.

THE MOST USEFUL OPTICAL FILTERS
THE MOST USEFUL OPTICAL FILTERS

AT THIS POINT, YOU MAY BE ASKING, "Why bother using optical filters at all in view of all the electronic filters available in-camera, the control of light offered through RAW file shooting, and the power of image-processing software?" That's a fair question. The answer can be found within your goals and personal shooting styles. If your goal is simply to correctly record colors and neutral areas, then careful use of your camera's white balance controls will at least get you into the ballpark, and shooting RAW files or using an image-processing program will often get you the rest of the way. But it is safe to say that most photographers have a preference for a certain look and want to interpret a scene or a subject in a unique way.

One reason to use optical filters would be if you are used to working with film and have developed a preference for the look of a particular optical filter. In my case, it is the amber colored 85b warming filter, a weak sepia filter, and an array of soft and atmospheric filters. If you know a specific optical filter will produce an effect you like, why not use it when the picture is taken instead of adding the effect to each image later in the computer? Or, to put it another way, where do you want to spend your time: taking pictures, or working in front of the computer?

For me, the picture taking experience is what photography is all about. I take pleasure in trying out new approaches, using different filters and filter combinations, creating unique compositions, and exploring the effect of different lenses on the scene and subjects before me. In short, it is where I have learned about style and interpretation. This learning continues to this day when I go out with the camera, for my personal work or on assignment. Photography truly is an open-ended experience if one is willing to try new things.

This begs the follow up question: What role does the computer play? For me, the computer is used to refine and extend what the camera captured or, in some cases, to do something that I knew could be more easily done in the computer. For example, adjusting the contrast, refining the Kelvin range of the light, or cropping an image to frame the scene differently. In addition, as specialized filter programs have become better and better with more and more options, I have found that these programs are a means to open up more possibilities in the captured image. Many of the specialized filter programs featured in the following chapters have become essential to me in bringing out different expressive elements in my photographs. Increasingly, it is in the computer where an image blossoms into its full potential as an expression of my style. But the old adage among computer people still applies to photographers: Garbage in, garbage out. If the camera image has little to offer, the best computer filter techniques may help, but will not necessarily save the image. There is nothing more frustrating than trying to make something out of nothing.

Another consideration is the question of whether there are real differences between using an optical filter on raw light or its equivalent in the computer. I can only offer my experiences in which certain filters, such as the many soft filters I like to use, produce results in raw light that cannot be duplicated in the computer. Sometimes this is a minor difference, but more often I find it is a significant one. Furthermore, many times the unique optical result teaches me something on the spot and directs me to take more variations of the shot. It plants a seed, if you will, similar to the effect of seeing how another photographer has interpreted a subject. Then there are the filters that can do something the computer cannot do, as in the case of the polarizer removing glare and the graduated neutral density filter bringing the sky into recording range, as discussed in the previous chapter.

So, with all this as prologue, here is the list of optical filters that I have found to be essential when shooting in color with digital cameras. (Black-and-white filtration methods are covered in another chapter, on pages 112–123.) This is a personal list, steeped in 30+ years of photographic experiences. It also reflects influences from

looking at thousands of pictures by other photographers that have often stirred me to try something different. As Ansel Adams said, "Photography is more than a medium for factual communication of ideas. It is a creative art." By the way, Adams used optical filters in his black-and-white work as a way of dealing with the limitations of film to record light in his Zone method of photography.

The Polarizer

"If you could use only one filter, what would it be?" No question—mine would be the polarizer. Why? Because it can reduce or remove glare for greater color saturation, deepen clear blue skies (or darken skies in black-and-white photography), and act as a neutral density filter in a pinch, all without shifting color.

The polarizing filter is actually a specialized form of light-blocking filter with a unique function relative to the fact that light will reflect in a polarized pattern off of certain surfaces. This is known as a glare reflection. There are two major styles of polarizing filters: linear and circular. The linear style is limited to use with manual focus cameras since it can interfere with the autofocus and metering systems in which a split beam arrangement is used. Consequently, the circular polarizer is the one to use with digital cameras. Circular polarizers are constructed of an inner, non-moving disk and an outer rotating disk. The crystal structure of these disks, when aligned in a certain way by rotating the outer ring, block or significantly reduce glare while allowing the diffused, image-forming light from the surface

to pass. Thus, turning the filter's outer ring controls the amount of glare absorption over a continuous range to a maximum effect. Since some of the light is being blocked during the rotation, a polarizer can also be used as a neutral density filter with an approximate range up to two stops of light reduction. The only thing to keep in mind is that it will also produce the other effects being discussed here. By the way, there is one special situation where a polarizer will effect colors, and that is when photographing rainbows. Turning the outer ring can reduce or even remove these colored light phenomena from a scene.

Some surfaces produce glare-like reflections that are actually direct reflections. These are not made up of polarized light, and therefore the polarizing filter will not have any blocking effect. In particular, unpainted

The removal of surface glare in the pictures on the right is the result of having sheets of polarizer material mounted in front of copy stand lights combined with an optical polarizer on the camera lens— a process known as cross polarization.

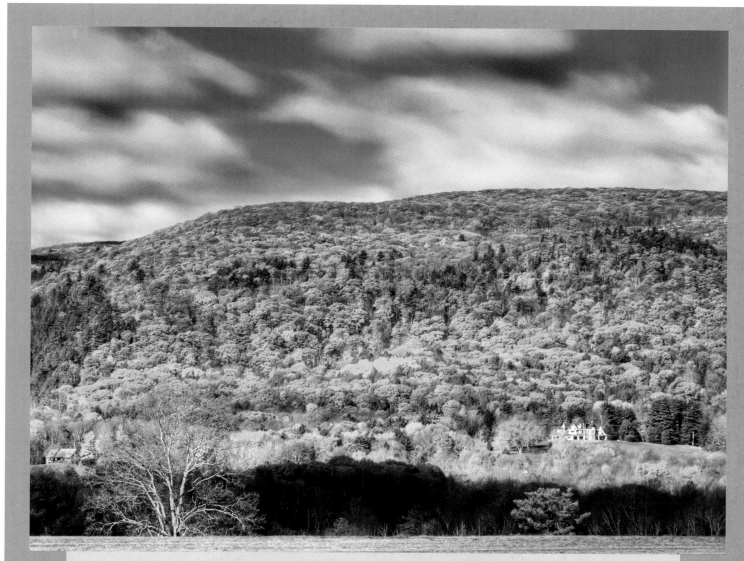

In this autumn landscape setting, the deep blue sky and the reduction of glare on the tree leaves from a recent rain shower produced higher levels of color saturation as a result of using a polarizing filter. The loss of light typical for this filter also allowed the use of a slow of 1/15 second shutter speed to slightly blur and soften the appearance of the fast moving clouds.

shiny metal surfaces characteristically produce direct reflections. It is also not uncommon for a surface to give off a mixed pattern of glare and direct reflections, in which case a polarizer filter will have only a partial effect. Finally, you must be at the correct angle to the surface producing the glare to get the full blocking effect of the ~~sually an angle of about 30 – 40° from the~~

~~uction is particularly useful when~~ ~~e polarizer on a copy stand. While using an~~ ~~zer on the lens will help reduce glare off of~~ ~~s, such as the pages of a magazine, a more~~

complete level of control comes with adding sheets of polarizing material over the light sources that have been set at an angle of about 30° – 40° from the copy table. This is called cross polarization, as seen in the example on the opposite page. The rotation mechanism of the camera filter can then control how much glare you want to remove.

Landscape photographers often make use of polarizers to lower the glare from the many shiny surfaces on a sunny day, thus increasing color intensity. This is especially dramatic when photographing fall foliage after a rain, as seen in the example above.

Sometimes, I will also change the camera's white balance to the shade or cloudy setting to add a warming effect, or to the tungsten setting for a cooler look, and then add a soft focus or diffusion filter to give an atmospheric feel. That adds up to two optical filters plus a mismatched white balance setting. Some photographers will cringe at the thought of using more than one optical filter, or dialing in the "wrong" white balance, but I would rather try different techniques to discover different interpretations than follow made up rules that very often reflect a narrow view of photographic expression.

The most common use of the polarizer is, undoubtedly, to darken blue skies and create more visual contrast with the white clouds. The effect can be quite dramatic, to say the least, as seen in several examples used throughout this book. When using a polarizer for this effect, only the portion of the sky area with polarized light will appear darker. This area can be determined by first pointing your index finger directly at the sun and then raising your thumb to form a 90° right angle to your index finger, as illustrated in Figure 4 (below). Now with

the index finger still pointed at the sun, rotate your hand so that the thumb cuts an arc in the sky. This arc will represent the maximum area of effect. From that line, the effect will decrease all the way to nothing in areas closer to the sun. One of the problems with polarizer sky filter effects is that the larger the segment of sky area captured, the more likely the decreasing polarizing effect will appear noticeable in your image, as seen in the bottom frame of the example at right.

⬆ Polarizing filters tend to be rather thick and can cause a vignette pattern by cutting off the light at the corners of the frame, especially with a wide-angle lens. For this reason, thinner circular polarizers such as the one pictured here are available from several manufacturers.

Figure 4

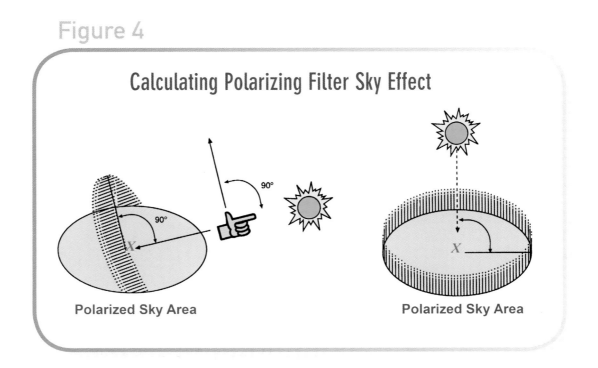

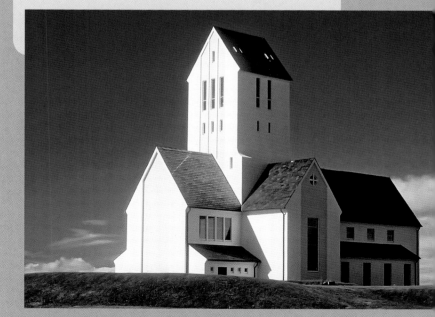

⬆ The darkening of the blue areas in a clear blue sky can be controlled by rotating the front ring of a circular polarizer, as seen in the first two shots of the steeple (top). One can also use a warm polarizer for the effect seen in the top right frame. Since the appearance of polarized light in the sky is not the same for the whole sky, the use of a wide-angle lens is likely to record the sky with uneven polarizing effects, as seen in the bottom frame.

☑ The especially darkened sky effect, produced by using a polarizer filter on this church in Iceland, was the result of selecting a moderate telephoto and a camera position to limit the amount of sky in the picture to just that area with polarized light.

Colored Polarizers: Several manufacturers offer polarizing filters with the addition of color. The effects can vary, from adding small golden highlights to an overall strong coloration, such as a dominant magenta or blue cast. Another more common variation is the warm polarizer, illustrated in the example above, in which the addition of weak warming material gives the effect of two filters in one.

⌃ Adding a graduated neutral density filter to a polarizer can really darken a clear sky to nearly black. I shot this photo of a small section of volcanic mounds off Canada's Baffin Island with a 400mm telephoto, keeping the total sky area limited to maximize the effect of the polarization.

Neutral Density (ND) Filters

A common way to decrease the intensity of light is to employ a neutral density filter. These filters use a neutral gray material to block all wavelengths of visible light uniformly. This design is based on the principle that neutral gray area absorbs all wavelengths of light equally, as discussed out in the first chapter of this book. The greater the density of the neutral density material, the more light is absorbed. ND filters come in four configurations: uniform, graduated, reverse graduated, and center spot, as seen in Figure 5 (right). The designation of each filter indicates how much of the light is blocked (see Table 2, below).

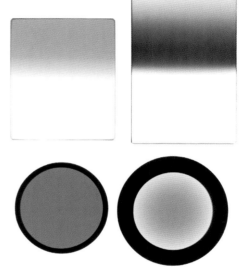

Figure 5

⌃ Here are examples of the different neutral density filter designs: graduated (top left), reverse graduated (top right), uniform (bottom left), and center spot (bottom right).

Light Loss with Uniform ND Filters

ND Filter	Light Loss	Filter Factor
0.3	1 stop	2x
0.6	2 stops	4x
0.9	3 stops	8x

Table 2

In this scene, a 0.6 (–2 stop) ND graduated filter was used to darken just the very top of the sky as a group of hunters set off across a frozen bay in Greenland with their dogsled.

Techniques to consider when using graduated optical filters:

☐ When using a graduated ND filter to reduce the brightness of a sky area, I base the exposure on getting the key middle values correct without any filter. The filter is then placed in the holder to hold back light only in bright sky areas, and the exposure is made. I also routinely take a no filter picture as a point of departure when evaluating various filter results.

☐ You do not have to use the whole color or neutral density field in the picture. The graduated effect will vary by raising or lowering the filter in the holder. I routinely take several shots with the filter at different levels in the picture. Note that aperture selection can alter effects. Extremely wide aperture openings, such as f/1.4 or f/1.8, produce less depth of field, and that tends to produce a slightly softer line of demarcation at that point where the graduated effect ends and the clear portion of the filter begins. On the other hand, stopping a lens down to f/22 or f/32 may make the point of demarcation more pronounced.

☐ The density of a graduated color filter can be increased by first setting the color filter in position and then adding a graduated ND filter set slightly above it to give a darker gradation to the upper area. I then move the filters up and down in different combinations and take pictures using several different combinations. The stacking of graduated filters in this manner saves having to carry around two different densities of the colored version.

Checklist

Soft Focus, Diffusion, Fog, and UV Filters

Selection of a particular soft focus or diffusion filter is a very individual decision that depends not only on the subject, but also on the style and preferences of the photographer. I tend to separate their use according to subject. Specifically, one set is for portrait work and close-up work, and another set is for landscape, cityscape, and other wide field settings, as described in the categories below.

With such a huge class of soft filters to choose from, how does one make a selection? Over the years, I have identified the specific effects I want and the filters that produce those results to my tastes. The list below does not cover every subject, and the descriptions are entirely personal interpretations. Nevertheless, my list may serve as a useful starting point for anyone who wants to develop their own filter list. It is also worth noting that I always take a no-filter exposure for reference.

Figure 9

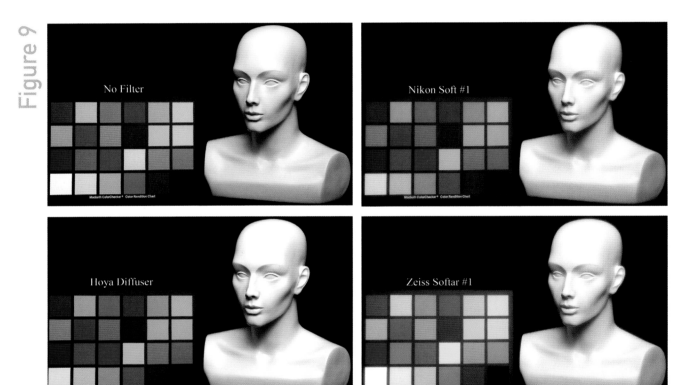

Figure 10

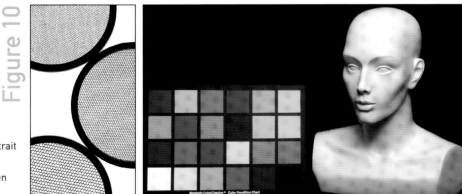

▶ Net filters, so popular among portrait photographers for generations, may cause a net pattern to show up as seen here when used on digital cameras.

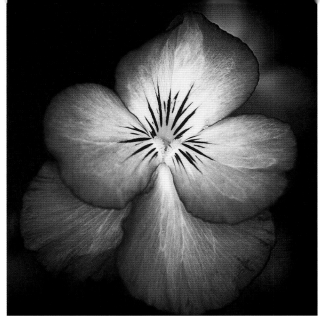
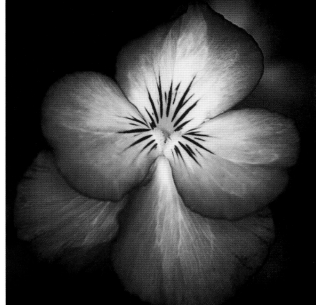
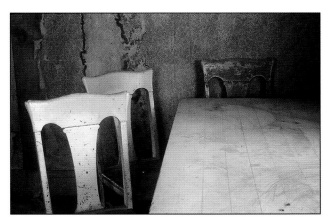
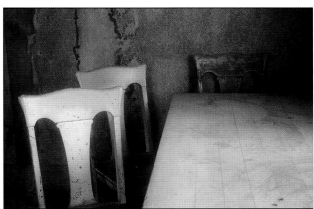

The top and bottom images on the left illustrate subjects shot without a filter. The top right frame was shot with a Nikon Soft 1 filter, and the bottom right frame was taken with a Softar 1 filter. It is important to keep in mind that the subtle effects produced by weaker filters such as these become more and more apparent as print size increases.

Category 1: This category is made up of filters with minimal effect to deal with small flaws (Figure 9 – left, top). The weaker soft focus filters I prefer for this category include the Nikon Soft 1, Zeiss Softar 1, Tiffen Soft/FX 1 and 2, and the Hoya Diffuser. I tend to use these filters with people to lessen skin blemishes, and also in close-up photography of flowers to just slightly soften the razor sharpness from a ring flash. In the example above, the sharp look of the first frame is slightly softened by a Tiffen Soft/FX 1 filter, as illustrated in the second frame; the sharp appearance of the chairs in the third frame is slightly reduced with a Nikon Soft 1 filter, as seen in the fourth frame, which better fits the subdued mood of the scene. Such small refining changes really become evident the larger the print that you make.

One note of caution: For years, portrait photographers have relied on various types of net filters to conceal minor facial flaws in portraits. Unfortunately, using these filters on digital cameras often results in a net pattern, as seen in Figure 10 (left, bottom). I have found this to occur inconsistently from camera model to camera model, so it is definitely worth testing this type of filter at different aperture settings on your own digital camera to see if it picks up the net pattern, as illustrated in Figure 10 (left, bottom).

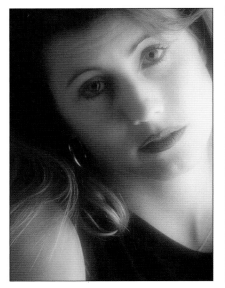 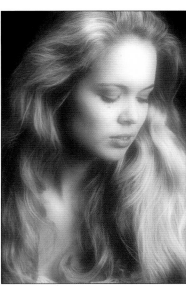

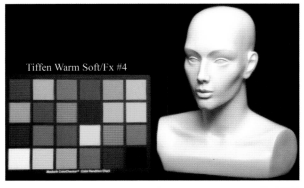

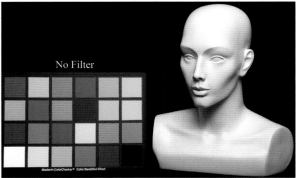

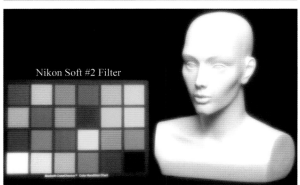

I always use a soft filter when photographing female models in order to render skin texture with a soft, even look. I shot the portrait on the left with a Nikon Soft 1 filter, and the one on the right was taken with a Nikon Soft 2.

Figure 11

Category 2: The filters that make up this category are somewhat softer while still maintaining a degree of contrast in the image (Figure 11 – above, right). In other words, loss of overall contrast is minimal to moderate. Filters such as the Nikon Soft 2, Zeiss Softar 2, and the Tiffen Soft/FX filters in grades 3–4 are included in this designation. I use these for female portraits when the purpose is to give a soft look, as seen in the example above with a Softar 2 used on the left and a Nikon Soft 2 on the right.

In the example at the top right of the opposite page, you can see my preference for taking the edge off the sharpness of automobiles and machines. The top frame is the unfiltered shot, and I used a Nikon Soft 1 in the middle frame. These filters also work well in conjunction with a strong sepia filter to give an old-time look and feel to the image, as shown in the bottom frame. Here, the Sepia 3 filter from Tiffen was used, which also contains the equivalent of a Soft/FX 2 soft filter.

Finally, the soft filters in this category are quite effective for reinforcing the very soft light common at dusk or dawn, especially when using more than one filter. I combined the Zeiss Softar 2 plus a Nikon Soft 1 to soften the lamp lights to a glow in the early evening shot of the building in the middle example on the opposite page. This combination also scattered some of the light in the highlight areas in the white frame of the building. Thus, it is a successful example of how I will sometimes combine optical filters for stronger or mixed effects.

▶ Use of soft focus filters is not limited to just people. I will often use them to soften objects, such as cars. The top photo is with no filter. I used a Nikon Soft 1 on the middle photo, and a Tiffen Sepia #3 that also contains a weak soft filter effect for the bottom rendering.

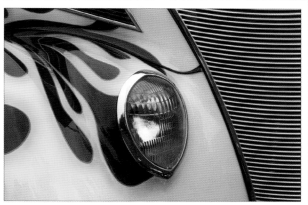

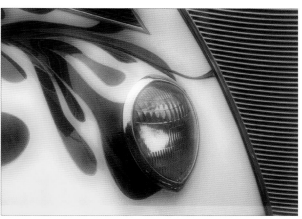

▲ Sometimes, I will combine more than one soft focus filter for a more dramatic effect, as seen here where I used a Zeiss Softar 2 and a Nikon Soft 1 together. Notice the wonderful soft glow around the brightest areas in the scene.

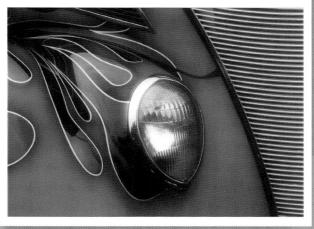

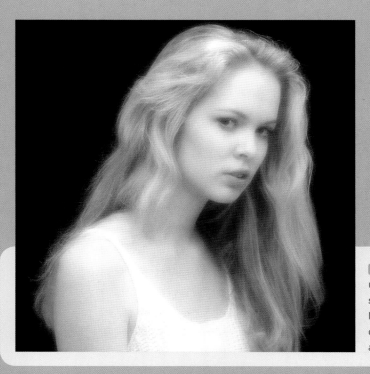

◀ Although the female portrait in color usually benefits from a warm look, I will sometimes select a cooler rendering later in the computer, as in this shot, originally shot with a Nikon Soft 2 filter and using a large soft box.

Category 3: I use the filters in this category for halo effects and general reduction of contrast (Figure 12). I find that the Tiffen Pro-Mist filters (in all grades) and the Black Pro-Mist filters (in higher grades) offer unique results for achieving moderate to strong halo/glow effects around strong light sources. They seem to do this while still preserving a good degree of sharpness in larger scene elements in the image. The left frame of the example below is a good example of this; a Tiffen Pro-Mist 4 filter formed glow patterns around the reflections in the building scene. Sometimes, the combination of two filters will also produce a weak glow, as tends to happen when a Nikon Soft 1 and 2 are combined, as seen in the right frame of the image set below, and also in the Salisbury Ambulance image in the middle of the previous page. I also turn to these stronger filters and filter combinations when I want to reduce the presence of smaller details in a picture so that larger shapes in reasonable sharpness can emerge as dominant elements. This is the case in the example at the top of the opposite page, where a Black Pro-Mist 5 (right) reduces the texture compared to the unfiltered exposure (left), allowing the basic shape of the pillars to dominate the picture.

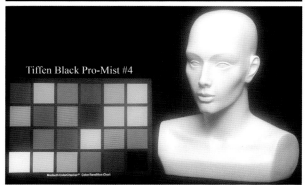

Figure 12

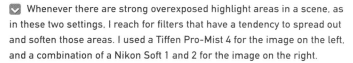
☑ Whenever there are strong overexposed highlight areas in a scene, as in these two settings, I reach for filters that have a tendency to spread out and soften those areas. I used a Tiffen Pro-Mist 4 for the image on the left, and a combination of a Nikon Soft 1 and 2 for the image on the right.

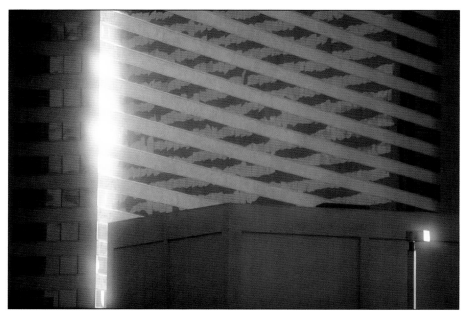

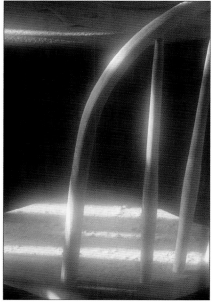

I will often use a very strong soft filter to eliminate texture and detail so that larger structures and shapes in a scene can dominate. The photo on the left is without a filter, and the one on the right was shot with a Tiffen Black Pro-Mist 5.

Fog and Mist Filters: I have not found an optical filter that can reproduce the subtle effects of real fog, such as that in the example at right, which shows a group of fishing boats in early morning fog. In general, fog and mist filters soften a scene with a very even appearance that lacks the subtle sense of depth produced in real fog.

UV and Skylight Filters: Many photographers keep UV filters on their lenses all the time for protection, so they should be added to our list of optical filters for digital cameras. I use a UV filter for protection when shooting near water spray on a beach or near waterfalls, or out in the snow or rain. And, to achieve a soft focus effect in a pinch, there is the time-honored trick of applying a very thin coating of oil from one's nose with a finger as evenly as possible to a UV or Skylight filter (never to the lens), which produces a slight, but noticeable, overall softening. This technique will often produce streaks from light coming in through a window. There are also times when I have been caught without any soft focus filters and have resorted to fogging the lens with breath and taking a series of exposures quickly as the fog dissipates. This is not always successful, and the results can be quite uneven.

Figure 13

☑ Close-up filters are basically filter-sized magnifying lenses. Unlike macro lenses and extension tubes, they do not result in a loss of light.

Close-Up Filters

Close-up filters are not actually filters at all; they are lenses that attach to a traditional lens like filters do, but are actually magnifiers that allow the lens to focus closer to a subject for a magnified view (Figure 13 - lower left). Essentially, this is the same process as when we use a magnifying glass in front of our eye. This is a much less expensive way to do close-up photography compared to purchasing a macro lens. There are two basic classes of close-up filters; the single-element types are very basic and relativity cheap compared to the second class of more expensive multiple-element designs that produce much higher quality images. Canon, Nikon, Leica, and a few other companies offer multiple-element close-up filters. These filters will maintain much of the image quality of the original lens, while single-element close-up filters will tend to show more degradation of lens sharpness, especially at the edges of the image.

The single-element close-up filters are rated according to their diopter strength. That is, using a numbered scale beginning with +1 and progressing to +2, +3, and so on. The higher the number, the greater the amount of magnification. It is even possible to combine two lenses. For example, a +2 and a +3 would be equivalent to a +5. In general, though, single element close-up lenses will degrade the sharpness of the image, especially with stronger versions.

The multi-element filters use different designations for the degree of magnification depending on the manufacturer. For example, Nikon's close-up filters have names specific to the size of the lens mount. Their 3t is equivalent to a +1.5 diopter and a 4t to a +3.0 diopter. The 3 and 4 Nikon series close-up filters fit 52mm lenses, while the Nikon 5t (+1.5 diopter) and 6t (+3.0 diopter) fit 62mm lenses. When not carrying a macro lens, I keep a 77mm Canon 500D multi element close-up filter (+2 diopter) in my bag that works very well with the large 77mm front on the 70–200mm f/2.8 zoom lens that I favor for landscape work.

I will often add a multi-element close-up lens to a macro lens to get even closer to a subject, as was done here using a 105mm macro lens with a Nikon 5t (+1.5 diopter).

For this close-up of the inner parts of a flower, I used a Nikon 6t (+3.0 diopter).

A bonus that comes with close-up filters is that there is no loss of light as a result of adding the filter to the lens, as occurs when focusing close with a macro lens or using extension tubes. The only real drawback to using these filters is that they limit the distance between the subject and the camera in which the lens can be focused. This is in contrast to having the complete focusing range from infinity to the closest focusing distance that is characteristic of a true macro lens. One of my favorite applications is to use the 5T and the 6T Nikon close-up filters on a 105mm macro lens in order to get very close when doing flower photography, as seen in the examples above.

Warming, Sepia, and Enhancing Filters

There are several optical filters that I prefer for warming up a scene over the effects of computer software. These include sepia filters, as well as the 85b conversion filter. Each gives a different form of warm look, and each is much stronger than the shade or cloudy white balance settings. I stopped carrying 81-series warming filters (my old time favorites) since switching to digital, and now reproduce their effects either in-camera with the cloudy or shade white balance setting or in the computer when processing RAW format files by simply changing the Kelvin temperature. However, I still carry Tiffen Sepia #1 and #3 filters for their unique look, and a Tiffen 105C Enhancing filter that really brings out red, brown, and orange coloration in the autumn. I also use a Singh-Ray LB "Lighter Brighter" Intensifier filter that generally raises the intensity of all colors. This filter is not as strong in its effect as enhancing filters made using didymium glass, such as the Tiffen version. I prefer the results that these filters give me in different types of lighting and with different subjects versus trying to get similar results in the computer. And again, one of the biggest advantages to using optical filters during shooting, for me, is that

if the color change I see on the spot is interesting, it may inspire me to try to exploit the scene further with different compositions.

Sepia filters are usually associated with an "old-fashioned" look, and they can certainly provide that result, but I have found that the weakest #1 version will also give a strong warming effect to bright mid-day sunlight. Try this filter in tandem with the shade or cloudy white balance settings to produce an even stronger warming effect, as I did in the example at right, top. Sometimes I will also add soft focus filters, such as the Zeiss Softar I, Nikon Soft #1, or a Tiffen FX #3, for additional mood effects. Once again, all these filters and filter combinations are done on the spot to see if the scene has more possibilities and therefore lead me to experiment with different compositions. This is how I worked when using film in the past based on what I saw in the viewfinder. Today, I can also see the results on the LCD screen to give a more complete picture of the final results.

The 85-series color conversion filters are strong warming filters that I use only when the scene needs to be rendered with an amber warm tone, as opposed to the stronger brown tone of a sepia filter. To the naked eye, it may seem that sunsets do not require such treatment but, frankly, I have seen more than my share of rather dull sunsets. Clouds, mist, or other atmospheric conditions are often the cause. So, when the color disappoints, my 85b filter comes out of the bag along with a 0.9 graduated ND filter or reverse ND graduated filter to hold back some of the sky's brightness. In the example at right, I needed only the addition of an 85b filter to perk up the color of the Miami Harbor scene.

◀ One of the great advantages of using software to warm or cool a scene is that you are able to recreate the feeling you had when the picture was taken. This is what I did for this early morning scene, using the Dark Sunshine filter from the special effects section of PhotoKit Color from Pixel Genius.

☑ This scene came from shooting five different exposures with a weak #1 sepia filter and my white balance set to the cloudy setting. The five exposures were able to record the entire dynamic range of the scene, and I then processed the images using Photomatix Pro HDR software.

☑ Believe it or not, this was actually a rather dull sunrise that needed an 85B filter to bring the color up to what I wanted. When the sun did appear, I was disappointed and almost moved on, but then tried using the 85B. The result was about 20 more shots with different zoom settings and compositions all because the filter made the difference.

Filter Factors

Since colored and neutral-density filters, as well as certain other filter designs, will reduce a portion of the light, a standardized measurement called a filter factor is used to indicate how much light is lost. The higher the filter factor, the greater the light loss and the greater the exposure adjustment required, as summarized in Table 3, below.

A common question is whether or not you should calculate the filter factor and adjust exposure accordingly, or whether the camera's meter will do this automatically. It has been my experience that light meters in most D-SLR cameras will usually give accurate readings with the filter in place, the exception being the graduated neutral filter design, noted earlier. However, if the metering system is not TTL (through-the-lens), you will have to calculate a correction to the camera's meter reading based on the filter factor. Even with TTL cameras, I would recommend testing any filter on your camera by taking a meter reading with and without the filter in place. Compare the loss of light registered by the meter with the filter factor. If the meter does not correctly compensate for the filter, use the manual exposure mode to meter the scene without the filter, then adjust according to the filter factor. If you wish to use an automatic metering mode, set the camera's exposure compensation dial for the difference you have

found by testing. For example, add a + 1 stop of light for a filter with a factor of 2 if the meter is not making this adjustment.

In addition to filter factors, some filter results will be dependent on the f/stop used. For example, the effect of many soft filters is greater at wider apertures. This is something the manufacturer will alert you to in the literature that comes with the filter. It should also be noted that the effect of a polarizing filter and its effective filter factor will vary depending on where you set the filter's rotating ring.

Mounting, Storage, and General Care

Filters are mounted on camera lenses using one of two methods: either in a round design that is screwed directly onto the lens front, or as rectangular shape that uses a bracket system with different size adapter rings to fit different size lens threads. These bracket systems can also be combined with screw-on filters. Smaller lens sizes can be adapted to larger filters or filter holders by using step-up rings. For example, a 67mm lens can have a 67mm to 77mm ring attached, allowing a 77mm filter to be mounted onto the 67mm lens front, as illustrated in Figure 14. The most efficient way to store threaded circular filters is to mount them to each other with male and female end "stack caps." Rectangular filters are best kept in individual pouches or small boxes, as seen in Figure 15. For point-and-shoot cameras, many photographers will simply hold the filter in front of the lens, since many of the lenses on these models do not have threads for accepting filters. The Cokin Filter Company has some unique solutions in the form of bracket holders screwed into the bottom of the camera, or filters that mount magnetically.

Table 3

Filter Factors and f/stop Adjustments

Filter Factor	Loss of Light (f/stops)
1x	0
1.3x	1/3
1.4x	1/2
1.5x	2/3
2x	1
4x	2
8x	3

Figure 14

Step-up filter adapter rings are for adapting larger filters to lenses with smaller thread sizes.

Caring for filters follows the same general procedures as caring for the front element of a lens; start by blowing off any debris before cleaning the filter. Standard lens cleaning fluids, lens tissue, and silk lens cleaning cloths can be used with glass filters. With filters that have multicoating, the manufacturer may recommend special cleaning fluids. Also be sure to follow the manufacturer directions for cleaning plastic based filters.

The temptation to over tighten a filter or filter ring should always be avoided, as it can result in a "frozen filter." If this happens, try gripping the ring with several fingers and the thumb distributed around the ring to apply even pressure around its circumference. Alternatively, place the filter face down into the palm of your hand and turn the lens using the whole surface of the palm to apply an even pressure on the face of the filter ring. This can also be done using the soft sole of a shoe or sneaker. Filter wrenches, which apply even pressure around a filter to loosen it, are also available from filter specialty suppliers.

Figure 15

This is my waist pack for work in the field, containing round filters mounted to each other with stack caps on the ends, a rectangular filter holder, and rectangular filter cases. The small pop-out gobo is used to shield the lens from flare.

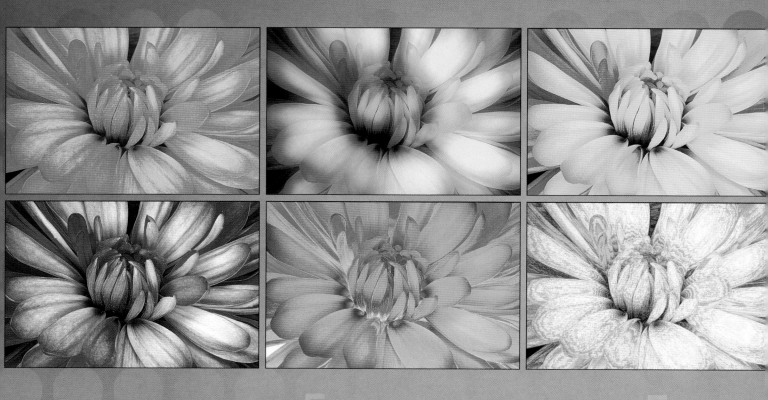

As the click of the shutter captures light, the click of the mouse now controls how colors will appear in that light.

3 Software for Color Correction and Refinement

ONE OF THE HALLMARKS OF DIGITAL PHOTOGRAPHY is that photographers now have near complete control over color from capture to print. The use of specialized filter programs, some as standalone programs but most as plug-ins, has made that control even easier. Plug-ins are accessed from within an imaging host program, such as Adobe Photoshop, Adobe Photoshop Elements, Aperture, Adobe Lightroom, or Corel Draw. In addition, all of these imaging programs have various native filters of their own that offer effects beyond just color correction. In the remaining chapters of this book, however, we are going to focus on learning about some of the specialized filter programs. These programs break down roughly into two classes. Smaller ones that offer a number of specific filter groups, usually marketed by small companies or individuals; secondly, much larger programs put out by well established companies, such as Nik Color Efex or The Tiffen Company's Dfx program, both of which offer a very wide variety of different filters.

In this chapter, we'll begin looking at the process of software filtration by examining a selection of programs that specialize in color correction. The approach here, as well as in the remaining chapters, is to first give a short overview of each selected program with examples of key functions, while also offering a few creative variations. In some cases, the examples will incorporate additional filter effects covered in other chapters. For example, we might add a soft filter to a color corrected image that was originally photographed using a polarizing filter. The examples included here are representative of the imaging controls available to today's digital photographer, which in many cases, means beginning with an optical filter and then further refining the image with specialized filter programs. Keep in mind that there is only enough space here to present a sampling of the selected programs' features. Resources for more information can be found by checking the websites listed for each program. But first, lets review how digital cameras record color and the critical steps for producing a high-quality, full-color image.

HOW DIGITAL CAMERAS RECORD COLOR
HOW DIGITAL CAMERAS RECORD COLOR

AS DISCUSSED IN THE FIRST CHAPTER, DIGITAL CAMERAS USE ELECTRONIC SENSORS TO TRANSLATE THE RGB WAVELENGTHS OF LIGHT INTO ELECTRONIC SIGNALS. Camera sensors are made up of millions of tiny pixel receptor sites that count the number of photon particles in the light and then convert this data into an electronic signal. The more intense the light, the more photons are counted at each pixel, and the stronger the signal coming from the sensor.

These pixels are basically colorblind, so there must be a way to sort out the colors in the light. The most common way of doing this is to have a chromatic filter in each pixel that records only the wavelengths of its own color. This is the same principle of subtractive filtration introduced in the first chapter. All the color data collected by each pixel is then assembled by the camera's firmware to produce the image that you see on the camera's LCD screen. The typical arrangement is to have pixels in a mosaic pattern spread out across the sensor in what is called a Bayer pattern (Figure 1, next page).

The missing color data for each pixel is generated by using mathematical instructions called algorithms. These algorithms set up extrapolations between the colors that were recorded to estimate what colors were not recorded. The more refined and sophisticated these algorithms are, the better the estimated results.

An exception to this mosaic form of recording color is the Foveon X3 sensor, found in cameras made by the Sigma Corporation (Figure 1, next page). This sensor

design is unique in that all three wavelengths of light are recorded evenly across the whole sensor. According to Sigma, "Similar to the layers of chemical emulsion used in color film, Foveon X3 image sensors have three layers of pixels. The layers of pixels are embedded in silicon to take advantage of the fact that red, green, and blue light penetrate silicon to different depths – forming the first and only image sensor that captures full color at every point in the captured image".

Tonal Values and Bit Depth

The basic indicator of color depth in a recorded image is its bit depth rating. Bit depth refers to the total number of possible color values that can be captured at the pixel photosites. As noted, for the Bayer pattern sensor, each pixel records only one of the three RGB colors. If the sensor is rated at eight bits, it can produce 256 different possible tonal values of the color it is recording. Remember however, that the 8-bit rating is for only one color. Thus, to determine what the total bit depth is for a full RGB color capture, we need to multiply the bit depth making up a single color channel by three. In the case of 8-bit color, it would be 24 bits (3 x 8 bits). The JPEG file format, for example, is based on 8-bit files.

To determine the total number of possible color tones as represented by bit depth in the 8-bit example, the 256 figure is multiplied by itself three times. So, the original 256 different tones of one color becomes a total of about 16.8 million tones (256 x 256 x 256 = 16,777,216). We humans probably need only about 10 million color tones to interpret a color image as having continuous tone. The exact amount of colors a person can discriminate between will vary according to many factors, but 16 million is probably at the top end. In photography then, 16 million-color tones is enough data to produce a full-color, continuous-tone image in the eye of the beholder.

In the early years of digital photography, the 8-bit per channel (or 24-bit RGB color bit depth) was standard along with the JPEG recording format. In addition, inkjet printers were capable of using no more than 8-bit files. Feed the printer anything larger, and it would literally throw away the extra data. Your typical computer screen also works with 8-bit levels, but digital photography is moving beyond this early standard. Today, D-SLRs have sensors that will record 12-bit and 14-bit color, depending on the model, and many a photography blog dabbles in the question of when we will we finally have affordable D-SLRs with true 16-bit capture. Such

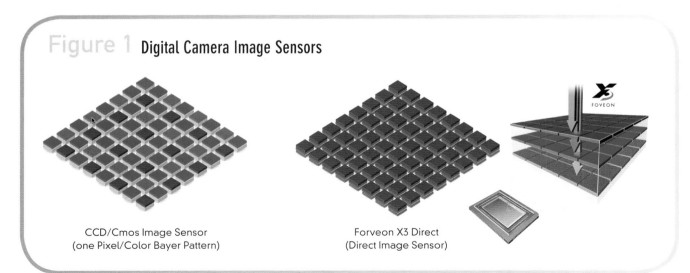

Figure 1 Digital Camera Image Sensors

CCD/Cmos Image Sensor
(one Pixel/Color Bayer Pattern)

Forveon X3 Direct
(Direct Image Sensor)

The most common method for recording color in a digital camera is to use a sensor with a mosaic pattern of pixel sites that each record only one of the RGB wavelength colors (left). The missing color data from each sensor site is then produced by interpolation based on the colors that were actually recorded to construct a full-color image. The second method (middle and right) is through the use of a Foveon X3 sensor that has three separate layers of pixels, each recording only one of the RGB wavelengths. Thus, this sensor records the light evenly across the sensor's surface.

◄ Shooting images with a higher bit depth is the better choice in situations where you will need to perform significant editing, as well as for scenes with a wide dynamic range, as seen here in this heavily edited sunrise picture taken with a camera set for 14-bit capture.

larger bit ratings, however, cannot be saved as JPEGs since these files are only able to save images with an 8-bit color depth. Save a 12-bit capture as a JPEG and you are throwing away any excess data it cannot store.

This is where the RAW file format becoming so popular with photographers comes into play. Why? First, it contains the raw data from the capture in an essentially unprocessed form. Second, it allows much more flexibility in processing key qualities like exposure, brightness, contrast, and color. Third, it is capable of handling higher color bit captures. So, if you want to record images at higher than 8 bits, you really should be using the camera's RAW file recording option and an appropriate RAW-file-reading software program. TIFF files are also capable of recording higher bit depths, but they have a notoriously slow write-to speed.

How much more color are you getting with high bit captures? A lot! For example, a camera that can be set for 12-bit capture is recording a total of 36-bits of full RGB color (3 x 12 = 36). This 12-bit capture is capable of producing a lot more color tones than the 256 possible with an 8-bit capture—4,096 for each color channel, to be exact! Typically, RAW processing software will give you the choice of outputting 12-bit or 14-bit files as either

an 8-bit or 16-bit image. The 8-bit file selection means any file with a higher bit depth reverts to 8-bit when processed, thus losing some color depth. Selecting the 16-bit option means that all the color data is processed and stored within the structure of a 16-bit file. It does not mean, however, that your 12-bt or 14-bit file has suddenly produced more original colors from the scene. Rather, it means that all the original colors captured have been saved.

So, if you only need 8-bits for a full color RGB 24-bit image with its 16+ million colors, why bother with a higher bit capture, especially since these higher levels can really slow down how fast a camera can save images? There are two good reasons. First, a higher bit depth means you can capture a wider dynamic range, from the darkest shadows to the lightest highlights, with detail. Depending on the camera, sensor, and bit rating, this can amount to adding a full stop of brightness to the dynamic range captured versus using an 8-bit capture. Second, and very important to any discussion of modifying an image with filter software, you have more headroom in terms of image quality when editing an image. For example, when adjusting the color, contrast, or brightness, the basic makeup of that image changes

◀ Making adjustments in such basic qualities as brightness, contrast, and color can reduce the amount of data in an image file. Smaller adjustments are less destructive, as seen in the small histogram of the middle frame where an increase in the contrast was used to improve the flat appearance of the original 8-bit file (top). Taking the adjustment to a more extreme level (bottom) results in a loss of data that now becomes visually obvious in the color shift in some of the rocks and the slight posterization of the water's surface. This is one of the limitations of smaller bit depth files, which offer less editing headroom to make such changes.

such that you are losing data during the editing, as seen in the histogram changes during the editing of an 8-bit image in the example at left.

All of us have seen how losing too much data while trying to make larger adjustments can lead to color shifts and posterization as less and less data needs to fill larger and larger image areas. So, you have to be very careful when image editing with 8-bit files. Can you make a reasonable quality, full-color image just using an 8-bit capture? Certainly, but the rub comes when you want to make changes to that image, especially significant changes such as those employed through creative use of color filtering.

Typically, pushing the limits of an 8-bit capture results in a breakdown in the realistic appearance of the image, as seen in the bottom frame of the example at left. Having more data on the other hand, such as in a 12-bit image, gives you editing headroom for

making these kinds of significant changes. This is one of the reasons many large changes can be made in a RAW capture before running into problems. The files have more data to work with, as well as having that data in an unadulterated form.

The trend towards using higher color bit images has been unfolding in an uneven fashion in that some programs are unable to use all their functions with these images, and only a few printers are able to make full use of this larger amount of data. But the direction is clear for professional photography, as well as for fine art and serious amateur photographers. Higher color bit captures mean more flexibility in editing and the potential for better image quality. Unless noted otherwise, all of the software programs in this book will process 8-bit images and larger bit capture images saved as 16-bit images.

SPECIALIZED FILTER SOFTWARE

MOST SOFTWARE FILTER PROGRAMS ARE AVAILABLE AS DOWNLOADS (though there are still a few sold as CDs or DVDs, complete with a printed manual), and virtually all programs offer free trial versions. I highly recommend downloading a program in its trial form and working with it for a reasonable amount of time before purchasing. Some of the programs available on the market are exclusive to either Windows or Mac systems but, for the purposes of this book, I have selected only those that are available for both platforms.

Typical filter software plug-ins (software that works in conjunction with a host software like Adobe Photoshop), as well as standalone programs, open with a dialog box containing controls and a small preview image that serves as a surrogate for the original image. Other than that, there are no real standards as to the way program features and controls are designed, so each program is unique. Adjustments are reflected in the surrogate image so you can judge the results. These changes can then be applied and saved to the image file that is open in the host program. If you do not like the outcome, usually a simple undo command in the host program will return you to the unaltered image. To be on the safe side, the image you are working on should always be a duplicate of your original. Most image-processing programs have a quick duplication feature, such as the (Image > Duplicate command) in Photoshop.

Installing Plug-Ins

When you decide to purchase a plug-in or experiment with a trial version, you will have to install it into a host program. Download the plug-in from the Internet; open the compressed .zip file that appears on your desktop and follow the on-screen instructions. Many plug-ins will automatically install into the Plug-ins folder in your host program when you follow the installation steps. However, this is not always the case and you may need to install the plug-in manually. Before worrying about this, though, double-check to see if the plug-in is in the right place. To do this in Photoshop, go to Applications folder for Mac or Program Files for PC, then open the Adobe Photoshop folder. Within that folder you should see a Plug-ins folder. Open it, and you can either place the plug-in directly into the folder if it has downloaded to another location on your computer, or you can simply verify that it has been installed correctly there. Other host programs have similar procedures for loading plug-in programs.

Once you install a plug-in, you should restart your computer. Most host programs need to be closed and reopened to recognize new plug-ins, and it is just a good idea in general to reboot your computer when you install new software. Once you reopen your host program, you can access the new plug-in. In Photoshop, click on the Filter drop-down menu and you should see it there.

Note: A few plug-in programs such as Pixel Genius' PhotoKit, require loading the program into the Automate folder of Photoshop (Plug-ins > Automate), so be sure to follow the loading directions for each plug-in.

Evaluating Filter Software

Judging the effectiveness of filter software begins with examining the types of tools provided within the program and ends with the quality of the changes to the original image. Here is a rundown of certain characteristics and functions that I have found to be important when working with one of these programs.

How much control do you have over filter effects?: Usually, the better programs provide a range of controls for making image alterations. For example, many programs have separate sliders for different aspects of a filter's effects rather than just a single general control. The notable exceptions are those programs that are based on a specific automatic action sequence. In programs of this design, user control is not available or is limited to preprogrammed stops in the action sequence if provided.

Tiffen Dfx software is an excellent example of a program that provides extensive user control in an easy-to-use package. The main filter categories are on-screen at all times, and can be seen in a row along the bottom of the workspace (see the image at right). Changes to the image can be seen in the center of the workspace, where you can choose to have the filter effect shown side-by-side with the original. The smaller square window just left of the filtered image shows a magnified view for a close-up inspection of the changes. Selecting a filter category brings up a set of preset options within that category, as illustrated by the small thumbnails to the right of the main image set. When you click on Parameters under the Window menu, various refining controls will also appear on the right side of the screen. You can use the Parameters controls to make changes in preset selections for brightness, contrast, blur, and more. The resulting customized filter effect can then be saved for later use. Tiffen Dfx also allows you to work in layers for multiple applications of different filters. Less extensive programs will not have such a range of specific controls, such an elaborate on-screen layout, or the choice of working in layers within the program.

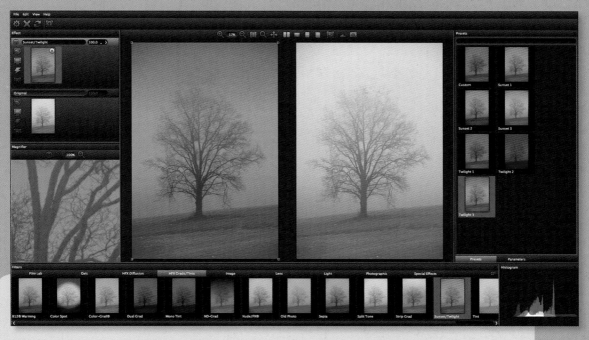

The open access appearance of Tiffen's Dfx software is seen here where I have selected the program's Graduated and Tints color group from the other groups shown on the bottom. I can easily go to another group, such as Special Effects, by just clicking on that window along the bottom of the screen. Also showing are the preset choices on the right and the results of selecting one of these, as shown in the side-by-side comparison illustrated here. I can also go to the Window menu and select Parameters, which will bring up sliders to modify the preset results (View > Window > Parameters).

Can results be easily replicated?: PhotoKit Color, a plug-in program from Pixel Genius, is a good example of an efficient smaller program with a simple layout and controls for a large number of preset choices. This program is unusual in that it is loaded into the Automate menu via Photoshop (Plug-ins > Automate) and accessed from the file menu (File > Automate > PhotoKit Color).

After selecting a filter from the available set (such as CC Correction illustrated in the image on page 78), you can see the result before applying it by clicking the preview box. Since all treatments are in the form of presets, it is very easy to obtain the same result again with another image. This is an important feature of any program; you should be able to return to the program tomorrow or months later with a new image and be able to produce the same effects. Preset choices are the easiest way to replicate an effect. If there are slider controls, then you will need to record the numerical settings that accompany most sliders. One of the

shortcomings of some programs is that the controls are only sliders with no numerical readout, making it tricky to exactly replicate a change in another image. I will often keep a file of notes, including a screen shot of the dialogue box adjustments for later reference, and save that file along with the processed image and my original RAW file.

How accurate is the preview image?: One annoying problem with some programs is that the preview (or surrogate) image that appears in the dialogue box showing the filter effects does not accurately represent the appearance of the final saved image. In other words, what you see in the preview box is not the same as what you actually get when the plug-in effect is applied. This can be a real drawback, especially when trying to achieve very subtle changes. I consider the accuracy of the preview image to be critical. This is definitely something to keep in mind when trying out a free demo of any software before you decide to buy.

PhotoKit Color from Pixel Genius is accessed through Automate under the File menu in Photoshop (File > Automate > PhotoKit Color). This brings up a dialogue box where you then select a filter set (CC Correction is shown here) and a specific filter effect (.30CC Yellow is shown here). The program is very simple to operate, and the effects shown in the preview are quite accurate in relation to what you get for a final treated final image. PhotoKit, a sister program from Pixel Genius, has the same general layout as shown here, except there is no preview function.

Does the software add noise?: It is not uncommon to notice additional levels of noise as a result of filter applications. In general, applying several extreme changes, or multiple applications of the same filter with any software, is an invitation to increased noise levels, as well as to the possibility of introducing other unwanted image artifacts. Noise levels, however, can often be mitigated with specialized noise reduction software (see pages 144–146).

Does the program have a help source?: Most programs will provide at least a link to a FAQ webpage, and sometimes even other info, such as a user's blog where you may find a useful question and answer exchange. Some programs also offer downloadable PDF manuals, or tutorials in the form of short videos. Nik Software, for example, supplies 60 or more short instructional videos on their site. Having some sort of help feature is essential, except with very simple, completely intuitive programs, or with an action filter that is totally automatic in its function.

STRATEGIES FOR COLOR CORRECTION
STRATEGIES FOR COLOR CORRECTION

THE MOST COMMON REASON FOR USING SOFTWARE FILTERS is to deal with the colors in the image, either for corrective purposes or to make a creative statement. There are a number of different approaches to rendering color correctly. As explained in the last chapter, matching the camera's white balance with the temperature of the light source at the time of capture is a good starting point. There are also color controls offered during RAW processing that allow you to make changes to image aspects, such as white balance and contrast, without causing significant or any image degradation. Even with these controls, however, there is often a need or a desire for further tweaking of the image, whether for better color correction or to introduce creative color effects. The following are some of the most common ways to color correct your images using software. We'll briefly review these strategies, then take a look at the software filters that will help you accomplish them.

Neutralizing Colorcasts

One of the simplest yet very effective approaches to correcting colorcasts is to properly render the neutral tones in a scene. As pointed out in the first chapter, people are most sensitive to colorcasts in neutral areas. Removing color from neutral areas is not a perfect solution but, in many cases, it may be all that is needed to convince the viewing eye that the scene is free of colorcasts.

Selective Color Adjustment

Sometimes you only need to adjust a single color, perhaps one that is most dominant in the scene, or one that defines the subject matter and needs to be rendered accurately. A common example is the rendering of skin tones in a portrait. Only a small amount of adjustment may be needed, but the results can be critical to the rendering of the subject. Even untrained observers are likely to notice incorrect colors in common subject matter, such as a yellow colorcast that causes a stop sign to appear slightly orange in tone. Adjusting to render such important tones accurately will invariably improve viewers' perceptions of the image in terms of how it is perceived as a correct representation of reality.

Warming or Cooling the Image

There are times when the colors in an image are more or less correct, but the scene or subject can benefit from a bit of warming up or cooling down. The idea here is not to shift the colors significantly, but rather to give the picture a little something extra to reinforce the desired mood. Some common examples of this are the warming of skin tones in a portrait, the warming of a bland sunset, or giving a snow scene an extra bit of coolness. This is a process that actually introduces a colorcast to help express something about the subject or setting.

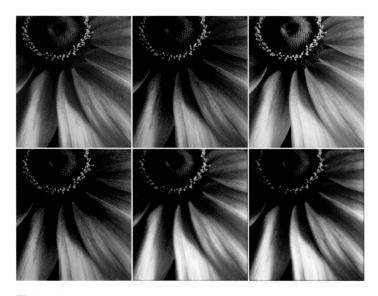

Significant changes in color can be accomplished quite easily by applying the various Light Balancing and Color Conversion filters found in specialized filter programs, such as Pixel Genius or Tiffen Dfx, as shown here.

COLOR CORRECTION SOFTWARE
COLOR CORRECTION SOFTWARE

LET'S HAVE A LOOK at these approaches to color correction using specialized filter programs, as well as taking some time to explore a few creative color filtration possibilities. Remember, the first step is to make a copy of the original image and work only on that copy. Also, before starting to make changes, take the time to evaluate the color makeup and decide what needs to be done on a general level. Finally, always be sure you have the original available for comparison. Most software programs will have a way to either make side-by-side comparisons or a means to easily undo/redo a treatment to make a back and forth comparison.

PhotoKit and PhotoKit Color: As pointed out earlier. Pixel Genius (www.pixelgenius.com) offers two Photoshop plug-in programs that contain color adjustment functions: PhotoKit and PhotoKit Color. Together, these two programs offer some 20 groupings, or sets as they call them. Within each set are a number of different specific effects. Of the two programs, PhotoKit, is less specific to color correction. It has eight programs, including B & W Toning, Burn Set, Dodge Set, Color to B & W conversion, Image Enhancement, Photo Effects, Tone Correction, and one program specifically for color correction called

Color Balance. It operates the same way as PhotoKit Color. We will use some of these effects in this chapter, and even more in later chapters.

It is the aptly named PhotoKit Color program, however, that really has more to offer for color correction including programs such as Color Enhance, Tone Enhance, CC (Color Compensating) Correction, CT (Color Temperature) Correction, and RSA Gray Scale Balance. Each of the five sets has a large number of preset effects to choose from. For example, in the Color Enhance set, there are 20 effects for refining color (see the image at lower left). As pointed out, the surrogate image in the dialogue box in all software programs should accurately represent the original image and reflect the changes that will be made in the final image. This is the case in both PhotoKit programs. In addition, all controls are described with either standard terms or with clear, descriptive phrases and are numbered to indicate strength (the higher the number, the stronger the effect). Thus, there is no problem replicating a result as long as you make a record of what you selected. Even though you can't modify any of the effects in either of the PhotoKit programs, the wide selection and degrees of changes offered are quite extensive.

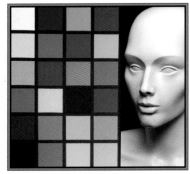
Original

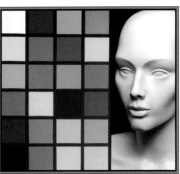
Lighten Red

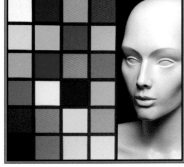
Light Green

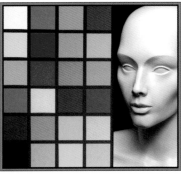
Lighten Blue

◄ The Color Enhanced Set from PhotoKit Color provides the means to change individual colors in an image. In these three examples, I just slightly lightened the hues of red, green, and blue and their closely related colors without producing any significant shift in the neutral appearance of the bust.

No Filter

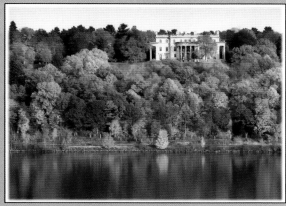

30CCMagenta + Soft Edge 6px

CT-O Full + Soft Black Rule Fat

RSA Gray Balance + Burn 1/4 top/bottom
+ 8 pix Black Rule

Here, I have illustrated one choice each from the following color sets: CC Correction, CT Correction, and RSA Color Correction. In addition, a slightly different border effect was applied to each of the four frames using the Photo Effects set from PhotoKit Color's sister program, PhotoKit.

No Filter

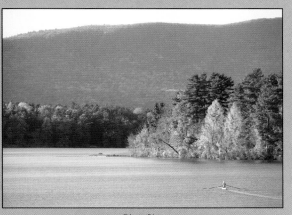

Blue Sky

The Special Effects Set of PhotoKit Color provides the means to enhance colors within a scene following common perceptions of those colors in the natural environment.

Sunshine

Three Color Transfer

PhotoKit Color has well over 100 specific color effects divided over its five different color sets—plenty of options. In fact, the adjustments are performed so easily and are of such high quality that many photographers prefer using them rather than going through the multiple steps for similar changes required within a general imaging program such as Aperture, Lightroom, Photoshop or Photoshop Elements.

Color Mechanic Pro: Color Mechanic Pro by Digital Light and Color (www.dl-c.com) is a visual-based program for making local color corrections and is especially simple to use for eliminating colorcasts; it also has the potential for making creative color changes. By "visual-based," I mean that the program is built on selecting and changing colors by a simple click and drag approach, then visually evaluating the results. This, as compared to other software programs that have scales with numerical readouts indicating the amount of change. You start by selecting a color from the scene, and this selection appears as a small black square on a color cube, as seen in Figure 2, below.

This square is then dragged to the new color on the cube, thus changing the appearance of the original color. In Figure 2 (below), this process was carried out to neutralize the blue colorcast on the car parked in the shade. The dialogue box has two images and two corresponding cubes. The image on the left is the original and the image on the right shows the result of removing the colorcast. An eyedropper tool is used to select the color area. This selected color then shows up on the color cube directly under the image. I selected a place on the right rear fender of the car, as marked with a red X in the top left frame of Figure 2, below. I then dragged the square on the cube representing this location to the zero color position on the right cube to remove the blue colorcast.

The full-sized picture of the car displays the before and after final results, showing how well this program translates changes seen in the dialogue box to the final image. If, after an initial neutralization, some color remains, simply repeat the procedure by selecting the area with the remaining colorcast. Also, when neutralizing colorcasts or changing any color, there

Figure 2 Digital Light and Color's Color Mechanic Pro is a program that allows the user to select and change a specific color or colorcast. In this example, I was able to quickly remove the blue colorcast on this car parked in shade by clicking on the fender and then moving where this appeared on the color cube to the zero color point. The side-by-side pictures in the dialogue box (left) show the before-after effects in the program while the larger split screen version (right) shows how well this change translated to the final image.

is always the option to only remove some of the color by not dragging the square all the way to the zero color point.

Wherever the mouse is placed on the image (or anywhere on the cube), a set of RGB numerical readouts in the dialogue box will tell you the amount of each of these primaries in the color selected. This is an easy way to check an area you suspect may have a weak colorcast, since a neutral area will have an RGB reading close to equal. Otherwise, there is no numbered scale for the changes you make. Rather, it is about judging changes visually with your sense of color while using these RGB readouts as a guide. There are, however, options for saving settings for a future application.

If you decide to change an individual color, you can see where this color appears in the whole image by first clicking on the color and then clicking the "Show Affected Region" box. The preview image will then black out, showing only areas where the selected color is in the image, as seen in the top left frame of the image to the upper right, where my selected area appears in the background as a red X.

Color Mechanic Pro has an interesting feature that allows you to see where a color you select appears elsewhere in the picture. That is the case where the color red under the "X" in the left image reappears in various places in the picture on the right while the rest of the colors are blacked out. So if you change the red in the "X" area, these other parts of the picture will also change accordingly.

According to the program's reference manual, you can make a total of 50 color corrections. If a color other than the one selected also changes, errant colors can be "locked down" by clicking on them in the original input image before making a change on the color cube. Since the program will handle up to 50 changes, I will often freely click on many colors to lock them down before clicking on the one I want to change and then dragging it to a new point on the color cube. This is how I was able to change individual colors in the example below.

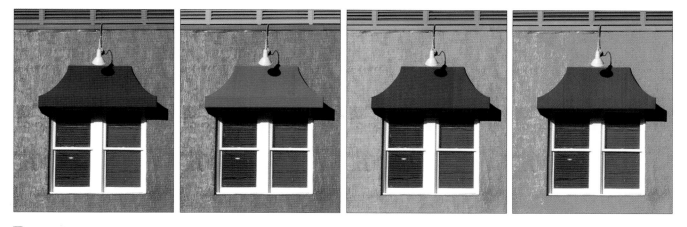

In this example, the ability of Color Mechanic Pro to lock down colors by clicking on them is demonstrated. The first picture represents the original image. The color changes made in the remaining three images were accomplished by first locking down those parts I did not want to change before altering one or more colors, as illustrated.

Color Mechanic Pro is a program that is certainly useful for fine tuning colors on a local scale, as well as for eliminating colorcasts, but it is worth noting that its graphic representation of color through the use of a chromatic cube is an educational tool by itself. One can't help but pick up a greater understanding of what goes into the mix of different colors by simply clicking on a color in an image to see where it shows up on the cube. You can then see the exact mixture of RGB colors by looking at the RGB readout figures.

iCorrect: The iCorrect programs by Pictographics (www.pictocolor.com) include five programs for color correction, four of which are for both Windows and Mac. They are: iCorrect OneClick, iCorrect Portrait, iCorrect EditLab Pro, and (their most advanced program) iCorrect EditLab ProApp. If you download the trial version of this program, you will find that the program's dialogue box (upper left corner) offers four sets of tools accessed by clicking on a numbered tab. Tab #1 is for color balance, tab #2 is for tonal range, tab #3 is for brightness/

Limitations of Neutralizing Colorcasts

Relying on neutralizing a colorcast as the sole approach to correcting color has its limitations. There is often a need for additional color corrections, or to give the image an additional color treatment to improve its appearance. I used Color Mechanic Pro on this image of a barbershop singing group to remove the colorcast, then applied the strongest warming filter (Warming #4) in the Color Balance Set in PhotoKit. This gave a pleasant warm look to the whole image, as seen in the final version in the bottom frame.

> ▶ The original image (top) was shot with the use of automatic white balance with an older D-SLR that did not have RAW capture and the result is an obvious blue colorcast. I dealt with the colorcast using Color Mechanic Pro by clicking on the bluest part of the wall and dragging this point to the center neutral point on the cube to remove the unwanted color (middle). I then used a PhotoKit warming filter from the Color Balance set (Warming #4) to finalize the image (bottom).

contrast/saturation, and tab #4 is for color hue. Figure 3 shows the effects of changing the color balance and the hue. This free trial demo applies watermarks to the saved image, as seen in the close up section of the car's roof and windshield in frame (a).

The original picture (top left) was part of a commercial assignment for an historical estate and was shot with a Nikon Soft #2 soft focus optical filter. The bright overcast day was great for subduing strong reflections off the metal work of the car, but it caused a blue colorcast that also subdued the reds of the brick background and the maroon color of the car's main body. In iCorrect EditLab ProApp, I opened tab #1 for color correction and, using the software's eyedropper tool, clicked on the front chrome bumper to get rid of the blue cast, as seen in frame (b). With this software, you also have the option of selecting an area and then changing how much it will alter color by the use of RGB/CMY sliders. At this point, the program has a visual-based approach similar to Color Mechanic Pro. With the

(a)

(b)

(c)

(d)

(e)

blue removed, the red of the brick wall improved and the maroon color of the car's body became more apparent, as did the green tint to the headlights and grill, all of which can be seen in frame (c).

I then decided to go beyond color correction and give the black metal parts of the car a stronger blue metallic cast. I clicked on tab #4 to bring up the hue function, as seen in frame (e), and selected a dark area on the car. Next, I adjusted the brightness and

saturation levels in this dialogue box and moved the blue color point around on the color wheel to produce the hue I wanted. But, this extreme adjustment caused the blue colorcast to return in the neutral areas so I again went to tab #1 and neutralized the cast by placing the dropper on the bumper to produce the final version seen in frame (d). Thus, version (b) is the color-corrected version and version (d) is my creative variation.

Rendering Skin Tones with iCorrect Portrait:

Because of the difficulty of correctly rendering the subtleties of skin tones—especially Caucasian skin tones—films and photographic papers have long been evaluated by how well they reproduce this key element. Digital capture and digital printing are also evaluated on the accuracy of skin tone reproduction. Needless to say, there is a range of interpretation that occurs among professionals in portrait work when it comes to rendering skin tones, to say nothing of the preferences of the paying customer. Consequently, the reproduction of this particular quality presents both a challenge and an opportunity for a range of interpretation.

Pictographics' iCorrect Portrait plug-in provides a very useful and quick approach when rendering skin tones in portrait work. Examine the middle photo on the top row of Figure 4, below. This is the original image. I made this portrait using a single strobe in a medium soft box positioned straight at the subject from just above the camera. In addition, I purposely positioned two full-length reflector panels on either side of the camera so that some of the red color from the background would appear as a colorcast in the face and arms of the subject.

The upper controls in the dialogue box (in the top left of Figure 4) are for setting black and white points, brightness, and contrast before going on to deal with color changes. To neutralize colorcasts, I clicked on the balance icon under Memory Colors, then clicked on areas in the picture that should be neutral (as illustrated in the lower of the two dialogue boxes in the top left of Figure 4, the resulting image of which can be seen on the top right, beside my original photo). The colors the program includes in Memory Colors are those that the average observer has a common general perception of.

Next, I activated the center "face" icon and clicked on areas of the face to find the desired skin color. This is done while avoiding areas with very bright highlights or deep shadows and instead seeking out evenly illuminated skin areas. In the three bottom frames of Figure 4, I produced a range of different interpretations of the subject's skin and hair using the controls just described. I also modified the results by clicking on Modify/Add Colors to bring up the second lower dialogue box seen on the left. This provided more control through the use of a sliding color scale. PictoColor iCorrect Portrait gives you plenty of range to handle a wide scope of preferences.

Figure 4

Kodak's Applied Science Fiction Software (www.asf.com): From time to time, a photographer will be asked to restore an old color photograph that has faded or to scan and print a color transparency or negative that has suffered a similar fate. One of the main problems faced in such restorations is a lack of knowledge about the original colors and the way the print or film recorded them. Kodak's Digital ROC, originally developed by Applied Science Fiction, is a program based on analyzing color gradients in an image to perform color corrections, as well as restore faded colors.

Applied Science Fiction, now owned by Eastman Kodak Company, first established themselves in the software world with the 1999 release of their Digital ICE, Digital ROC, and Digital GEM products, known collectively as Digital ICE Cubed. The ICE software removes dust and scratches while GEM reduces excessive grain and ROC restores and corrects color. All were initially available only as bundled software with certain film and flatbed scanners. AFS then released a Photoshop plug-in version of Digital ROC and Digital GEM, along with a new program called Digital SHO that is designed to improve shadow and highlight areas. To apply color correction to an image, ASF recommends using both ROC and SHO, beginning with ROC.

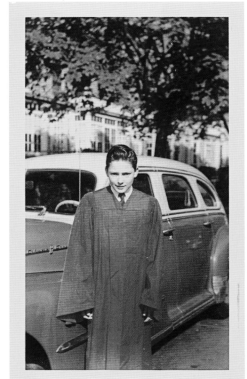
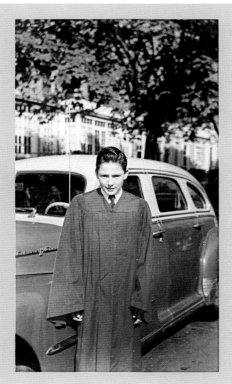

The print of the young man on the left in the ROC dialogue box was taken in the early 1950s. It has obviously suffered color fading and, in the process, has also gained a very strong overall warm colorcast as a result of the dyes fading unevenly in the print. I gave it a restoration treatment using ROC's automatically calculated settings. There are also controls to make adjustments manually, and I did some further tweaking, but I found that the original automatic setting worked best.

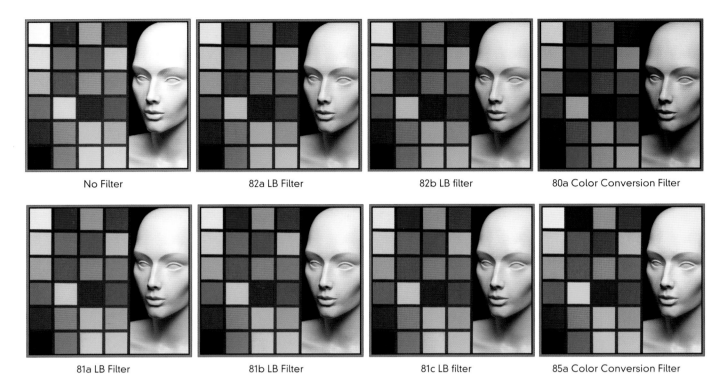

No Filter	82a LB Filter	82b LB filter	80a Color Conversion Filter
81a LB Filter	81b LB Filter	81c LB filter	85a Color Conversion Filter

Here, you can see the progressive effects of Light Balancing and Conversion filter changes possible with just the click of a mouse.

Tiffen Dfx: The Tiffen Company (www.tiffen.com) has a long history of producing one of the widest ranges of optical filters in the photographic and movie industries. When it comes to applying the software equivalents of such optical filters as the cooling, warming, and conversion groups, as well as a host of other common color optical filters, the Tiffen Dfx software has it all. According to Tiffen, the software engineers spent a lot of time making accurate digital duplications of their optical filter color line. It offers more than a couple hundred choices in total. I frequently use this program whenever I want to add a warming or cooling effect, or to enhance color, as seen in the many applications featured in the image at right.

The Tiffen Dfx software also has the equivalents of such standard filter groups as the Color Compensating (CC) filters, Rosco Gels (intended for use over light sources), and GamColor Cine Filters, as well as filters based on Kodak's Wratten line, as seen here in the Dfx dialogue box.

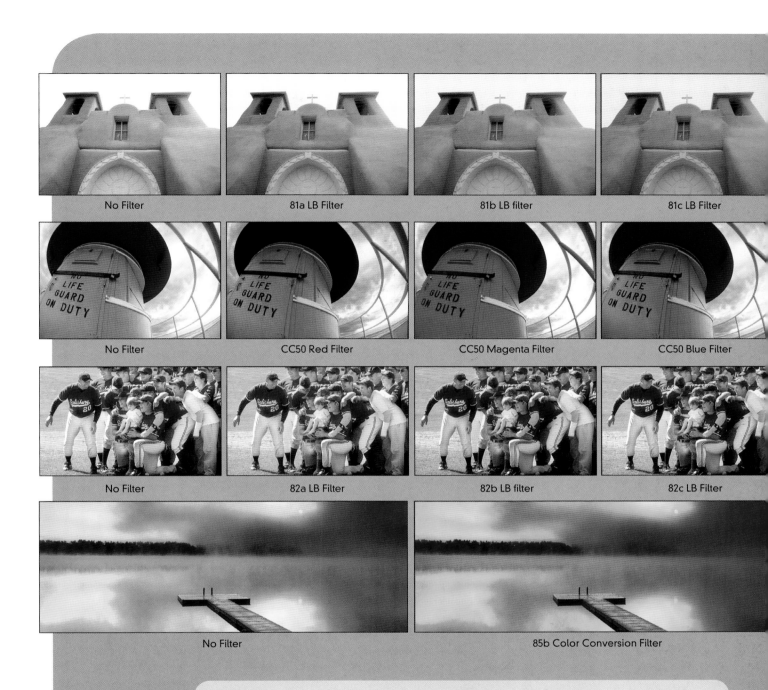

No Filter | 81a LB Filter | 81b LB filter | 81c LB Filter

No Filter | CC50 Red Filter | CC50 Magenta Filter | CC50 Blue Filter

No Filter | 82a LB Filter | 82b LB filter | 82c LB Filter

No Filter | 85b Color Conversion Filter

For each of these images, I simply clicked on the filter I wanted and applied the preset. Top Row: The original picture was taken on an overcast day, so I used the 81-series warm Light Balancing filters to restore the amber color of the church to different degrees. Second Row: To enhance the colors of the station, I used red, magenta, and blue Color Compensating filters at the maximum strength. This caused an obvious colorcast in the white clouds that I neutralized using Color Mechanic Pro. Third Row: I shot this image late in the day, producing a very warm rendering. I then applied different grades of the cool 82-series Light Balancing filters to remove varying amounts of warmth. Bottom Row: I added an 85b Color Conversion filter to significantly boost the feeling of warmth in this image. This filter offered strength beyond what could be done with the strongest of the Light Balancing warming filters.

U Point Technology from Nik Software: When an image requires only a global adjustment, such as a lowering of the overall brightness or removing a general colorcast, there really isn't a need to isolate any parts of the image. If you do have to move into a section of the picture for a local adjustment without affecting other areas, then some sort of selection tool or technique is needed. This can be as simple as using a lasso tool to isolate a specific area, or as complex as making a series of masks and working on separate layers.

This is where Nik Software's U Point technology comes in (www.niksoftware.com), with a selection mechanism that gives the photographer the means to change brightness, contrast, saturation, and color in a very specific way through the use of exact control points. According to Nik, these individual control points "are interdependent and communicate to combine and blend enhancements naturally, which can be easily adjusted or undone at any time, regardless of the order in which the change was made." Changes with U Point technology can be accomplished without having to draw a selection, make a mask, or work on a layer.

While the technology behind U Point is complex, using it is quite simple. The first step is to decide what you want to change and then set the U Point mechanism on that area. Once this is done, a series of lines appear, each a sliding scale that you can move back and forth to increase or decrease the quality selected. U Point technology is in all of Nik's software products, thus providing a very easy way to make local adjustments in their software applications.

In this example, I selected a representative green area in the background, just behind one of the Monks Cap flowers. I used the B slider to lower the color brightness of the whole background; the image area affected is indicated by a circle that can be adjusted using the top line of the U Point mechanism. The area can range from a very small selection to coverage of the whole screen. I set the circle to 100% coverage for the changing the whole background, and the software then looked for similar pixels to change throughout the picture.

Here, you can see just how selective U Point technology can be in an image. I selected a shiny area on the leaf in the lower right of the plant, setting the point on the brightest area that I could see in the magnified view loupe window in the lower right corner. I then moved the B slider until the shine was lowered, and this move also slightly lowered the contrast.

Just which areas of a scene are being affected by U Point technology can be seen by clicking on the function just completed in the list on the top right of the dialogue box. The right screen will then black out except for the area being changed.

Viveza from Nik Software: When it comes to difficult color correction situations that require local applications, Nik's Viveza software is an outstanding product. This software is also very effective at fine-tuning brightness and contrast. All of this is based on Nik's remarkable U Point technology (see pages 90–91) that allows the photographer to easily isolate and change virtually any part of a picture. Viveza has gained a lot of acceptance for its ability to alter the brightness and contrast levels of specific areas in a picture. In this chapter on color correction and refinement, however, we will focus on the ability of this program to control color using one of three approaches: (1) lowering the exposure of a selected color to make it darker, (2) selecting the color from the U Point RGB choices, and (3) selecting a color from a drop down color palette.

In this example, the eyedropper tool allowed me to change the hue of the trees.

Compare this change with the use of an enhancing filter with the same subject on page 17 shot originally many years ago on Kodachrome film with a Tiffen Enhancing filter. The fact that Viveza was able to make these changes in just three or four clicks of the mouse, without masking or using layers, was very impressive.

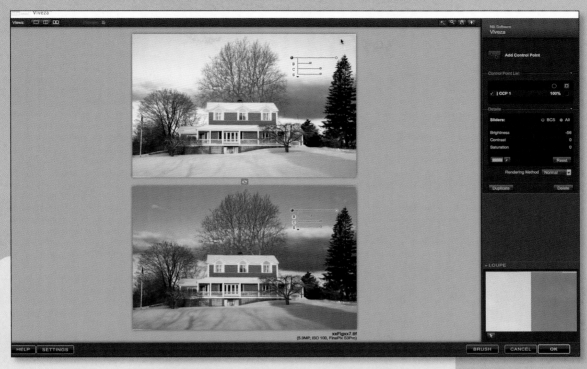

In the Viveza dialogue box, I selected the blue-sky area using the U Point technology. I then moved the brightness slider just slightly to deepen the color.

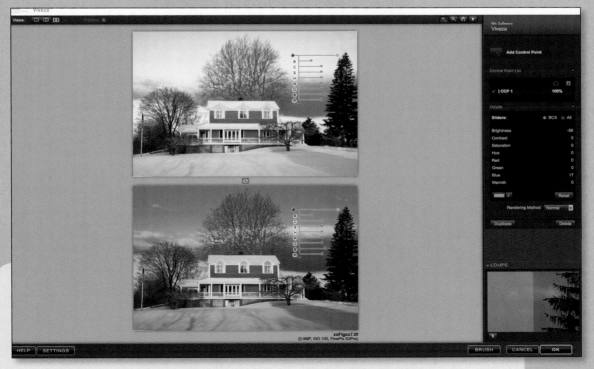

Next, I selected the blue color slider within the U Point controller and gave the sky a different hue of blue.

Employing Multiple Software Programs

Even though the majority of the examples covered in this chapter emphasize the use of "one click" programs, it is assumed that there will often be a need to tweak brightness levels, adjust contrast, and add sharpness after color correction has been applied in a specialized filter program. In a more complex example of color correction, the Siamese cat in the image set below was a grab shot at ISO 1600 under very weak mixed fluorescent and indirect window lighting. I used a 50mm lens at f/1.4 on a 6-megapixel D-SLR that did not have a RAW file option. The result was the noisy, poorly color-balanced image in frame (a). The first step was to use Digital SHO to adjust the exposure, then Digital ROC software to correct for the green colorcast and restore colors. The image looked much better after that, as seen in frame (b), but I felt that the subject's eyes were not the brilliant blue they looked when the picture was taken.

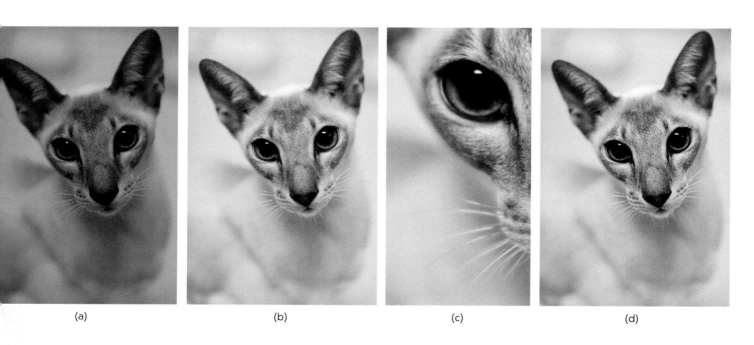

(a) (b) (c) (d)

With a difficult image like this one, you will often find yourself with more than one problem to solve. Thus, it may be necessary to use more than one program to achieve the results you want in the final image. For the finishing touches, we'll turn to two other programs to help out. First, Andromeda RedEyePro software (www.andromeda.com) gives you the option of easily changing eye color, in addition to removing redeye without affecting the catch lights. In the example above, I tweaked the color of the cat's eyes with just a bit more blue in frame (c).

Finally, I applied Nik Sharpener Pro. This program is designed specifically for sharpening an image for output by inkjet, laser, and thermal dye transfer printers. To avoid any changes in the smooth background area, I only selected the head of the cat for sharpening. The final image appears in frame (d).

CONCLUDING REMARKS

The software programs featured in this chapter are certainly not the only ones that can be used for color correction and refinement. Indeed, there are many programs that can perform these tasks. The selection I have included here is intended to familiarize you particularly with the concept of using specialized filter programs for color correction, as well as some other changes. Each program has its own unique way of approaching color correction that sets it apart from the others. I encourage you to look around and consider other programs that may fit your workflow better, or which may simply be more to your liking. Finally, let's not overlook the natural filtration effects of different atmospheric conditions, as seen below where the orange coloration of a sunset and the cool look of a pre-dawn fog can stand on their own.

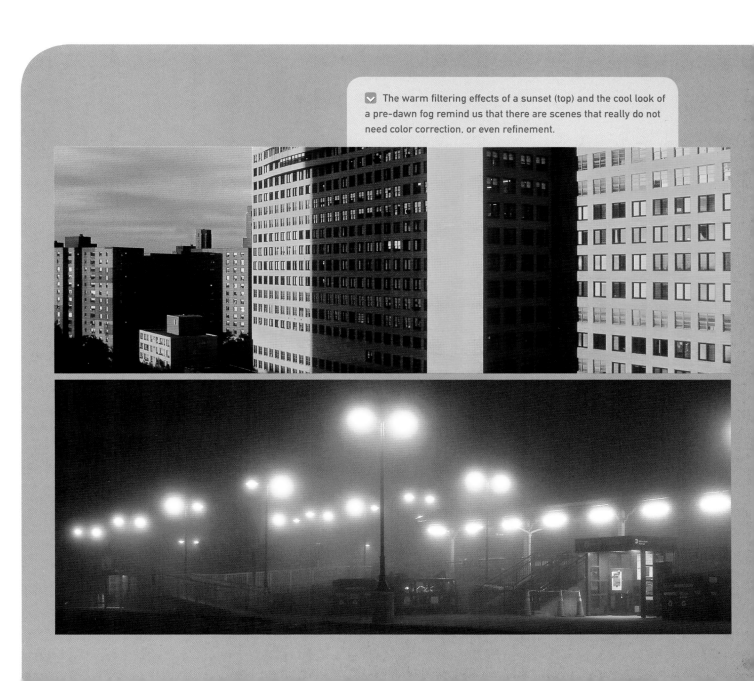

The warm filtering effects of a sunset (top) and the cool look of a pre-dawn fog remind us that there are scenes that really do not need color correction, or even refinement.

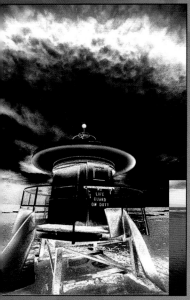
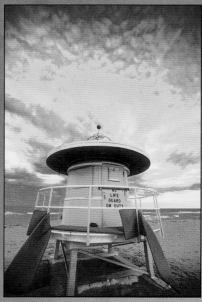
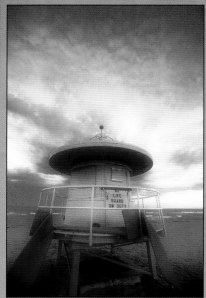
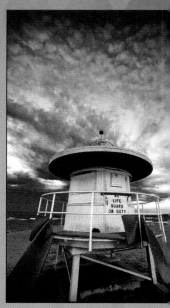

Color is the most complex of light's qualities, capable of conveying so many different impressions. On the opposite end of the spectrum, viewing the world in grayscale can reduce a subject or scene to being viewed in the most simple, and perhaps most expressive, quality of light.

4 Creating Visual Impact and Special Effects

IN THE LAST CHAPTER, the discussion concerning color was focused primarily on the need to produce color-correct images, as well as refining some of these color correction methods for more creative applications. In this chapter, the emphasis will shift to using color filtration software to add impact to an image, as well as exploring the effects of removing the element of color. These filter effects can be applied in a range from subtle to dramatic. We will consider several specific color and black-and-white filtration techniques, including the use of graduated color filters, establishing impressions of atmospheric color, and looking at specialized treatments such as solarization and infrared.

Nik Color Efex Pro has the most extensive selection of color filters effects, while Nik Silver Efex is perfect for black-and-white photography. Both of these programs are featured extensively in this chapter, as is Adobe Photoshop's simple color-to-grayscale conversion and some of the special effects offerings in Tiffen Dfx. As I have mentioned previously, these featured programs are certainly not the only ones available. Do your own research and experimentation to find what works best for you.

HOW AND WHEN TO USE CREATIVE COLOR FILTRATION
HOW AND WHEN TO USE CREATIVE COLOR FILTRATION

BEFORE WE BEGIN LOOKING AT THE WAYS COLOR CAN BE USED BEYOND ITS CORRECTIVE ROLE, it is worth thinking about the possible implications that using color in this way can have on your photography. Transformation of the colors in a photograph enables you to create a variety of alternative image versions, each with varying impact that has the potential to alter the viewer's perception of the photography. We photographers are now in a world where the click of a mouse will produce very real and significant changes in our images. Such options can act as harbingers for altering one's approach to photography, though I am certainly not suggesting you change your personal photographic style; rather, use the tools available to you to enhance and maximize your stylistic expression.

Producing various color effects with specialized filter programs is so easy that it can challenge a photographer's sense of how color can be used. When the purpose is to render a color correctly, there are standards that one can refer to. In this chapter, however, we are moving into a realm in which color is used to express something beyond accurately recording a subject. So, are there any rules once we stop using color in its correct form? Well, yes and no. There are guidelines that, when followed, increase the chances that the use of a color will add the desired impact to the image, as opposed to inhibiting the perception of the subject matter or confusing the viewer.

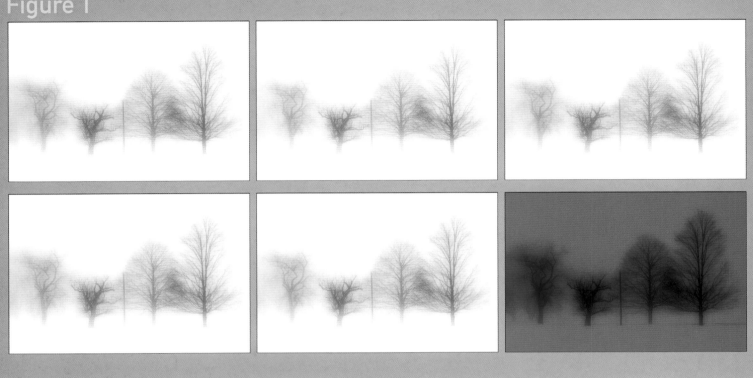

Figure 1

Let's take a simple example of a high-key snow scene rendered in five different ways, as seen in Figure 1, above. The original capture is in the top left frame, and the remaining five versions were produced using different options in the Nik Color Efex Pro Paper Toner filter. Before making such changes, it is useful to first think about what makes the original scene work as an image. The obvious answer in this case is the high-key softness, the ethereal look of this snow scene in which the trees have been rendered as very soft visual elements. To add to this image, it is important to work with the soft rendering, being careful not to detract from it.

As you can see, the application of a very subtle coloring (employed in most of the frames) does not compete with the original look. Instead, it adds an additional visual element that is in harmony with the softness. This use of subtle color reminds me of the delicate hand-painted photographs of the 19th century. Now consider the strong turquoise color in the last frame. Here, color has really subverted the main visual theme, virtually eliminating the softness as the key visual element. So, with this example as an introduction, let's look at some guidelines to consider when moving beyond color correction to use color for creative purposes.

USING GRADUATED COLOR SOFTWARE FILTERS
USING GRADUATED COLOR SOFTWARE FILTERS

The basic idea behind using a graduated color filter, be it optical or software, is to add color to an otherwise bland area or to boost colors in a scene. The most popular use of these filters is in sky areas, although foregrounds can sometimes benefit from added color, as well. The key to a successful result has to do with the following considerations, all based on maintaining a balance between the existing visual elements and the added color.

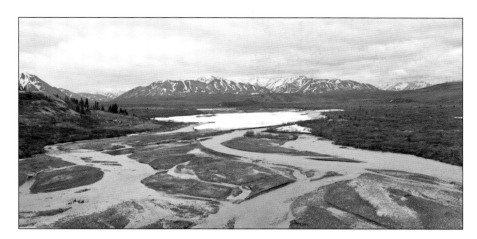

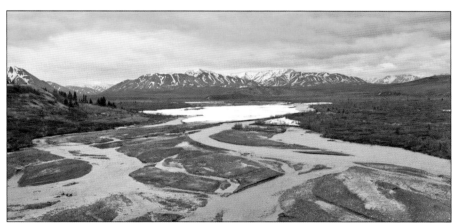

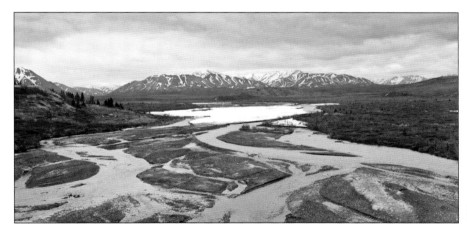

Figure 2

Color Harmony

One of the most important points to keep in mind is the question of how appropriate the added color is to the picture. How well does it fit with the other colors in the scene? For example, dropping a strong orange sunset graduated filter into the sky of a midday scene with its otherwise neutral lighting is not likely to make sense to the viewer. Much more appropriate would be the use of a blue color, or some variation of a cool hue. This is

the case in Figure 2 (above), where I took the original overcast scene of Alaska's Denali National Park (top frame) and added an orange graduated filter (middle frame). Certainly, this color is dramatic and has a visual impact, but is it in harmony with the more subdued colors of the scene? Does it make sense?

The addition of a weak cooling filter to the sky was the more appropriate approach, as shown in the bottom frame of Figure 2. The most harmonious approach when

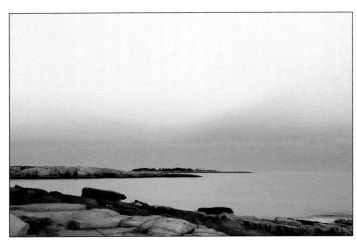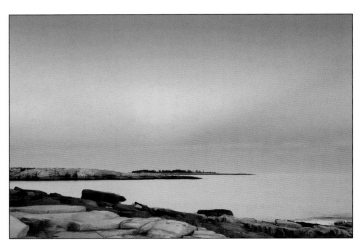

Figure 3

adding color with a graduated filter is to compliment the color that already exists. This elevates the impact of the color without conflict. Adding a warming filter to an image of a sunset or sunrise, where the original shot was weak in its warm coloration, is another perfect example of this, as is adding to the magenta coloration at dusk or dawn.

In the seascape setting just after sunset in Figure 3 (above), I added a moderate graduated magenta filter, then darkened the upper sky area. I matched the magenta filter color to the original magenta color in the scene by using the "User Defined" choice in Nik Color Efex. This filter provides an eyedropper tool with which to do the sampling. You can then control the filter density and degree with which you blend the filter into the scene.

In Figure 4 (left), I applied three different color graduated filter effects to the original scene (first frame). I used filter presets in the Tiffen Dfx program for the different colors. What do you think—do the applied filter effects extend or conflict with the impact of the original sunrise scene?

Figure 4

No Filter

Dfx Grape 4

Dfx Cranberry 3

Dfx Blue 4

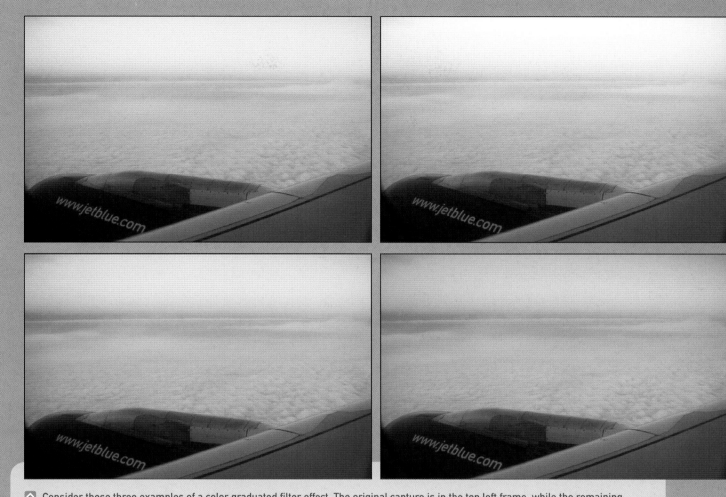

Consider these three examples of a color graduated filter effect. The original capture is in the top left frame, while the remaining three variations were made using Nik Color Efex user defined color graduated filters to sample the existing magenta color. Which do you think works best? Or would another density be a better choice?

Balancing Color Density

A second important consideration is matching the strength of the filter to the scene, which is very much a matter of style and personal taste. Some photographers prefer very weak graduated color filter effects, while others favor a stronger application. There is no strict rule here, but there are some things to consider. For example, if the scene is made up of subdued colors, such as in a misty morning setting, the use of a very dense color filter may interfere with the tonal balance of the image. On the other hand, a scene with strong, bold colors will probably need a stronger filter; a weaker color in this situation would likely add nothing to the picture.

Degree of Coverage: Graduated color filter software allows for some choice as to how much of the picture area will receive color. This is the equivalent of moving an optical graduated filter up and down in the filter mount to localize the effect. The potential for trouble comes when the filter's color begins to merge and possibly interfere with other colors in the scene. In general, I have been happier with the flexibility of using an on-camera optical graduated color filter when it comes to controlling coverage.

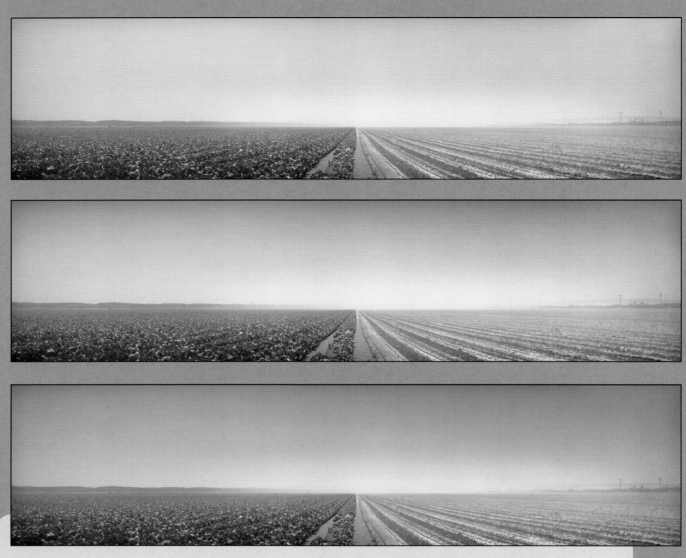

⌃ In these images altered with graduated color software filters, notice that the delicate line of dust along the horizon in the original capture (top frame) is beginning to be encroached on in the middle frame, and even more so in the bottom frame.

Skies without Graduated Color

Most landscape photographers have had to deal with a situation in which an otherwise interesting setting is offset by a pale, colorless sky, as seen in the top left photo in Figure 5 at the bottom of the opposite page. One option is to use a graduated ND filter—as I did in the top middle frame—to apply some density to the sky area. A series of graduated color filter effects could also be used, as previously demonstrated. The problem here is that there is only a sliver of sky showing, and that invites the problem of running into the tree line with the filter effect. Instead,

it might be more appropriate to simply add uniform color to the sky, as I did for each of the remaining frames (top right, bottom left, bottom middle, and bottom right). This can be done by first selecting this area, then making chromatic adjustments in a general imaging program. Again, the question of color appropriateness to the rest of the scene must be considered. In your opinion, do any of the color additions to the image work for the scene? I prefer the cool blue cast in the far right image on the bottom row. To me, this rendition most closely reflects the cold morning when I took the picture.

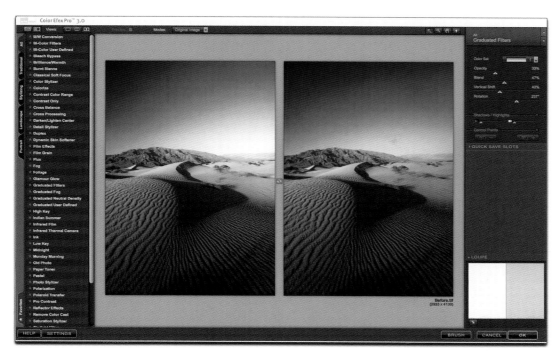

◀ Some software programs will allow you to rotate the placement of a graduated effect, which can be used to compensate for an uneven sky area as a result of using a polarizing optical filter. This is the case here, where the uneven sky resulting from the optical filter was corrected, to some degree, by using the filter rotation function in the Nik Color Efex Blue Graduated filter.

Figure 5

 In this example, an 85b color conversion (or sunset) filter increased the warm mood of a sunset shot from the North Rim of the Grand Canyon.

ATMOSPHERIC COLOR
ATMOSPHERIC COLOR

WE HAVE ALREADY DISCUSSED THE USE OF STRONG COLOR CONVERSION FILTERS within the context of helping to balance the color of the light with the camera settings but, as pointed out, digital photographers generally do not bother using optical conversion filters or their close cousins, the light balancing filter group. Instead, they either obtain a color balance by matching the camera's white balance to the light source and/or adjust the color later in the computer. The contrary approach is to introduce a strong overall color to a scene in order to take advantage of the impression that color can convey in the mind of the viewer. I call this type of coloring atmospheric color.

When I want to employ even stronger forms of atmospheric color, I use Nik Color Efex, which has a series of Midnight filters that are especially effective. Here, for example, I gave this image the impression of being shot at night with an extreme blue colorcast added using the Nik Color Efex Midnight Blue filter.

Whenever I consider adding atmospheric color to an image, I often turn to the Tiffen Dfx program and its extensive corrective filter choices. I prefer to add atmospheric color to images that already have a certain mood. The most common examples, for me, are when the normally warm light of a sunrise or sunset, or the cool look of dusk or dawn, are rather weak, detracting from the desired feeling I want an image of that time of day to convey.

In the midnight color images to the right and at the bottom of the opposite page, I added a slight softness to the color boost using the Nik Color Efex Classic Soft filter. The most successful uses of atmospheric color are very often the product of more than one filter. In particular, adding a soft filter, using layers of burning and dodging, or creating major shifts in contrast all reinforce the overall impression of an extraordinary rendering. In other words, you are not relying on just color for the final effect, but are using it as one of several tools to build a unique and unusual impression.

One of my favorite approaches to creating atmosphere in an image is to deal with certain contradictions between filter effects and the main visual elements in the picture. As an example, consider the overall atmospheric effect of fog and the way it renders everything with a soft veil that mutes colors. Fog is a kind of depth-of-field control; the further an object is from the camera, the more muted its color, brightness, and contrast will be. I very much like this effect, but sometimes I want to see what happens to the overall impression when certain colors are enhanced. This is the basis of the image treatments in Figure 6 on the following page.

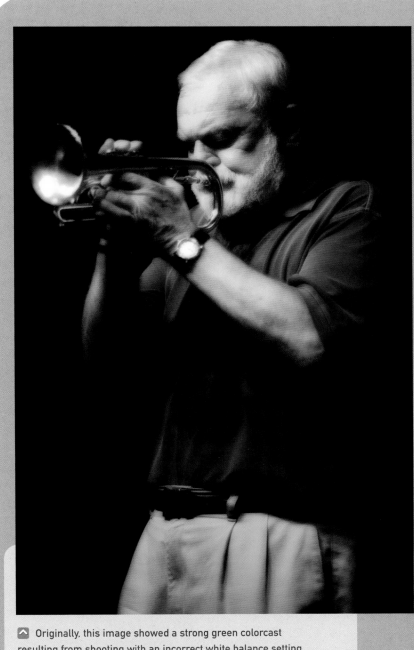

Originally, this image showed a strong green colorcast resulting from shooting with an incorrect white balance setting. So, I decided to work with that and amplify the mood the green color created by using the Color Efex Midnight Green filter.

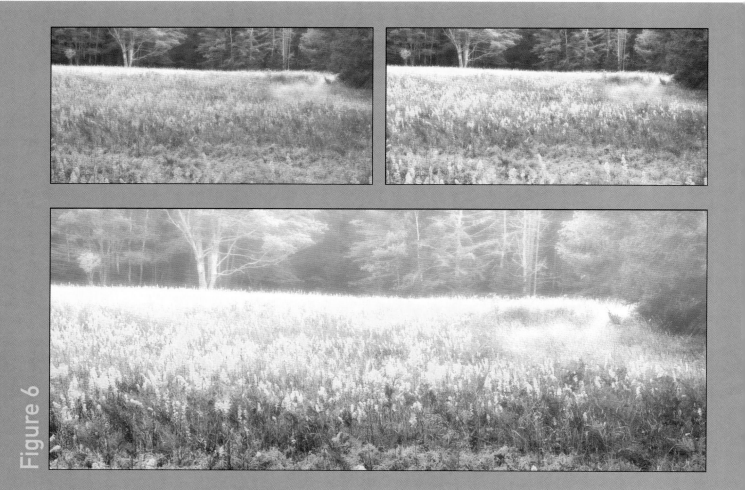

Figure 6

Figure 7

I photographed the field of goldenrod in Figure 6 (left, top) very early one misty morning in the Petit Manan National Wildlife Preserve in Maine. I cropped the original capture (top left) to a panoramic format to reinforce the wide expanse of the field. The low contrast in this frame was due to a weak mist that reduced the color intensity of the flowers, but my memory was of strongly colored flowers scattered in the field. Here was a situation where my brain was giving importance to these colors while the camera was correctly recording their muted appearance. So, I decided to produce what I remembered in my mind's eye and began to use different filters within Nik Color Efex to increase the impact of the colors in the field. This program offers a high degree of local control for applying various filters using their patented U Point technology (as discussed on pages 90–91).

First, I selectively enhanced the darker colors in the scene using the Indian Summer filter (Figure 7, bottom left of the opposite page), followed by a boost to the lighter colors using the Foliage filter. The results of these applications can be seen in the top right frame of Figure 6 (top of the opposite page). The increase in color intensity, however, began to give the row of yellow flowers in the immediate foreground too much visual weight. At first, I went back to the U Point tool and lowered the intensity of the yellow in this area but, in the end, I decided to remove this row of foreground flowers by cropping the image tighter to further reinforce the panoramic effect. Lastly, to add to the sense of depth, I added some additional mist to the top half of the picture using the Graduated Fog filter. Unlike most other fog filters, the Nik Color Efex Graduated Fog filter allows you to place the fog where you want it rather than just apply it over the whole picture. You can see the final image results in the bottom frame of Figure 6 (top of the opposite page).

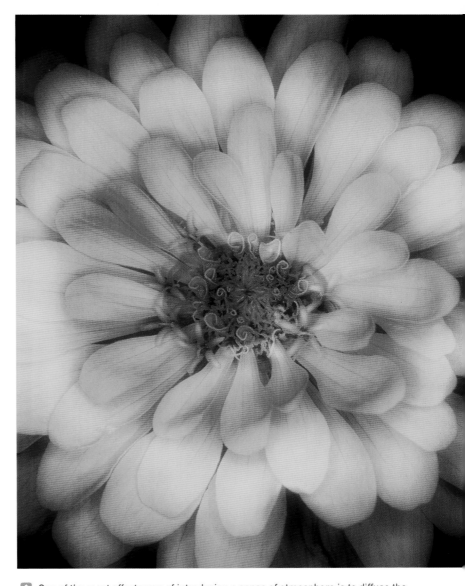

One of the most effect ways of introducing a sense of atmosphere is to diffuse the sharpness of a subject and soften the overall appearance of a bright color. This is what I did here with this ring-flash flower close-up, using the Tiffen Dfx Black Pro-Mist filter #8. In addition, I also selectively increased the density of shadow areas and lowered the brightness of the midtones using the Curves tool in Photoshop.

SPECIAL EFFECTS
SPECIAL EFFECTS

IN THE DARKROOM DAYS, ACHIEVING SPECIAL EFFECTS LIKE SOLARIZATION required time and patience, as well as trial and error. Photographing in infrared (IR) color or black and white required special films and careful processing. In the digital era, however, all these treatments require only the right software filter and, in the case of true IR photography, a converted camera.

For the examples in this section—most done with Nik Color Efex software—I am clearly moving well beyond the realm of reality. Here, colors can emerge as the dominant visual element, played out among the other graphic elements of the scene. This is strictly a trial-and-error world in which there are no rules, a few guidelines, and lots and lots of surprises.

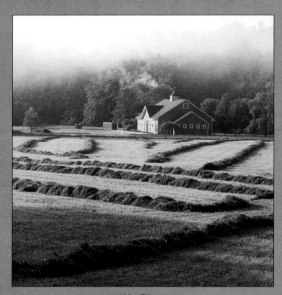

No Filter

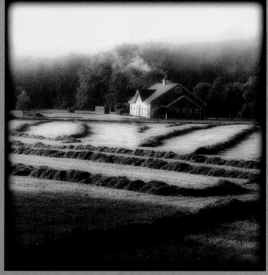

Color Efex Duplux color + Dfx Photographic Vignette

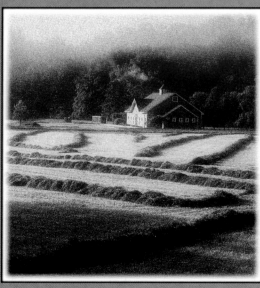

Color Efex Photo Styler Russet + Photoshop Noise 20%

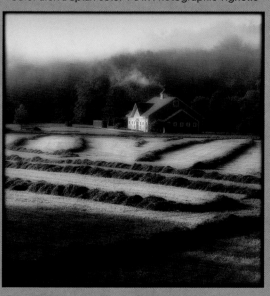

Color Efex Midnight Blue + Graduated Blue Color Efex

◄ Here is another example of the ability of filtering software to add more than one effect to an image to increase the expressive role of color. The first frame is the original capture; in the second frame, I used the Color Efex Duplex Filter and the Tiffen Dfx Vignette filter; for the third rendition, I used Color Efex Photo Styler Russet then added the Tiffen Dfx Grain filter; for the final frame, I used the Color Efex Midnight Blue and Graduated Blue filters.

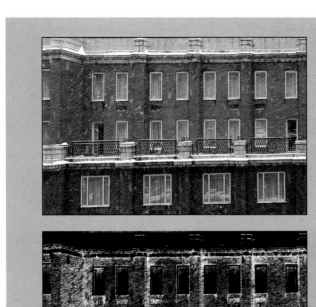
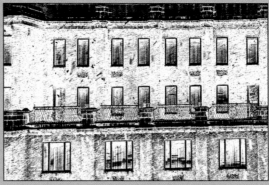

This example demonstrates the impact of the Lapse Time slider in Nik Color Efex and its range of effects on my original capture (top left) of a building in light snow. For the top right rendition, I set the slider to 25%; I used 50% for the bottom left frame; I went up to 75% for the bottom right frame.

I have found that subjects and settings with definite lines and shapes, like the head stones in this image set in Figure 8 (below), seem to work better than soft, diffused subjects when employing strong color or other special effects. The leftmost image below is the original capture, and I then used the Nik Color Efex Solarization filter to produce the three additional renditions using this filter's three controls: Method, Saturation, and Lapse Time.

Each of these controls is capable of radically changing the image in different ways. The Method application controls the overall look of the image with a choice of six color and six black-and-white selections. The Saturation slider then raises or lowers the saturation of colors. Lapse Time alters the way the solarization flips between positive and negative renderings.

Figure 8

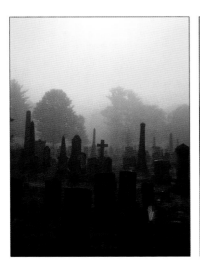
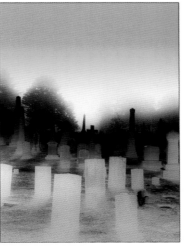
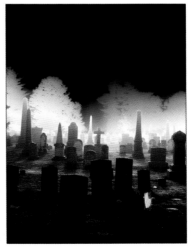
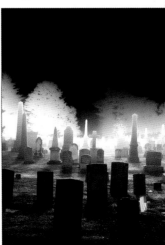

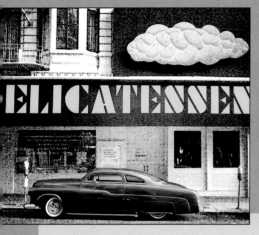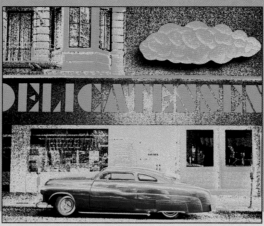

⬆ The first image in this set is a black-and-white image saved as an RGB file that I "hand colored" by selecting various areas of the picture and then adding color in Adobe Photoshop. I then used the Color Efex Solarization filter to produce the result in the middle frame. In the final frame, I applied the Color Efex Weird Dreams filter.

Once you begin using special effects filters, such as those featured here, you will see for yourself that the variety of outcomes will be far beyond the uses of color for adding impact that were covered in the first half of this chapter. You could spend days (if not weeks!) experimenting with all the controls in the Nik Color Efex and Tiffen Dfx programs alone, not to mention the myriad other software programs and plug-ins out there, and still not exhaust the possibilities.

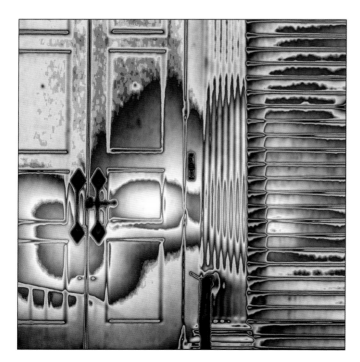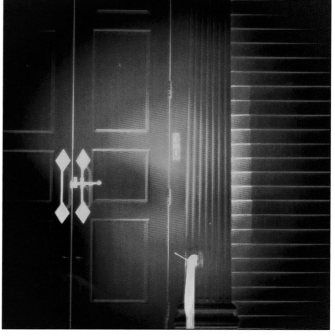

⬆ Exploring these more extreme filters further, I applied the Nik Color Efex Flux filter to a rather ordinary picture of a door to a public building in the first frame. To that same original, ordinary picture, I added the Infrared Color filter to achieve the extraordinary result seen in the second frame.

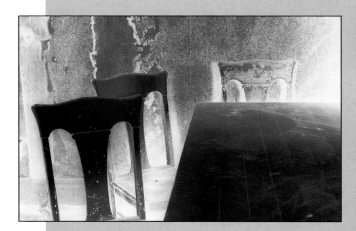

There are also some interesting special effect color filters in the Tiffen Dfx program that are worth noting. The left top frame shows the X-Ray filter effect on an image of a table and chair. I applied the same filter treatment to the flower in the left bottom frame. The picture on the right shows the Dfx Night Vision filter treatment of two scientists in an isolation room; the added grain is part of the filter's effect.

Here, you can see the results of double solarization, which is another option. The image on the left is the result of one solarization treatment using the Nik Color Efex Solarization filter, and the frame on the right shows the effect of using the exact same settings again for a new result.

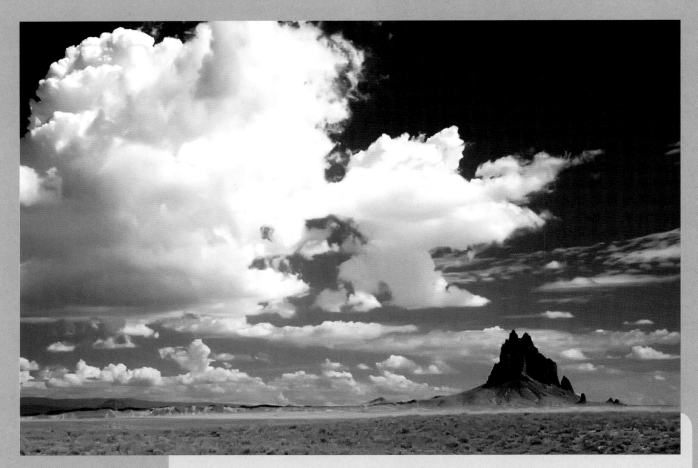

In this example, I used a strong Red 25 optical filter to darken the sky, resulting in nice contrast between the clouds and the sky area. The filter also lightened the red in the foreground. The large Ship Rock formation was rendered dark, even through it, too, had a red coloring, because it was in shade. The effect of contrast filters is strongest in bright, even lighting, and greatly reduced when dealing with shade areas.

BLACK-AND-WHITE FILTER TECHNIQUES

A BLACK-AND-WHITE PHOTOGRAPH IS THE MOST ELEMENTAL FORM OF THE PHOTOGRAPHIC IMAGE with its basic language of black, white, and various shades of gray. And yet, despite these simple components, some of the most profound and striking images ever made have been created in this medium. Perhaps it is because such a limited set of visual elements with which to produce an image places more emphasis on content and composition.

Additional processes are often used to add color to black-and-white images, such as toning with sepia, selenium, or cyan, to name just a few, as well as the time-honored practice of hand coloring. You can also add soft filter and graduated filter effects or, for that matter, some of the special effects filters demonstrated in the last section. There is a strong tradition in black-and-white solarization that extends back to the work of Man Ray in the 1930s, for example. And certainly not to be overlooked is the unique effect that infrared black-and-white photography produces, such as ghostly white trees and grass that stand in stark contrast to jet-black skies.

In the days when black-and-white film was the primary medium for photographers, they refined the tonal range using colored B&W contrast filters. Following the principle of subtractive filtration, these filters increased or decreased the density of the gray tones that represented individual colors in a scene. This ability to render a specific color as a lighter or darker tone of gray provided the means to separate out different parts of the picture. The results can range from subtle to dramatic, depending on the filter choice.

This same approach can be used with a digital camera that has a black-and-white recording mode (sometimes called grayscale or monochrome, depending on your camera model). In fact, the option to capture images in black-and-white now seems to be quite common among the newest D-SLRs, probably reflecting the increased general interest in black-and-white photography among digital photographers. Another motivation for camera manufacturer's to include a black-and-white shooting mode has surely been the improvements in black-and-white print quality from inkjet printers. It was not that long ago when getting a neutral black-and-white result out of an inkjet printer required an expensive RIP software and/or special monochrome inks. Today, a photographer can make beautiful black-and-white prints using a variety of papers and inks from inkjet printers made by a number of companies.

Creating a Black-and-White Image

There are several ways to produce black-and-white digital images. If you're wondering how to transport your black-and-white film or prints into the digital age, they can be scanned to produce a digital file for printing or altering using image-processing software. Scanning is fairly straightforward; simply tell the scanner whether you are scanning a reflective document (a print) or film and select the quality of the grayscale output desired. (Check your scanner's instructions for more details.) You can also scan color images or negatives and convert them to grayscale using the grayscale conversion tool

in Adobe Photoshop or another image-processing program. For original digital images, you will start with either a black-and-white file created in-camera, or take a color photo and convert it to grayscale.

Choosing and Using Black-and-White Filter Effects

The reason for using colored filtration is to control the separation—and therefore the contrast—between the grayscale tones that will represent the colors in the final image. For example, black-and-white film photographers rely on moderate to strong colored optical filters in yellow, orange, and red to help darken blue skies. This produces a stronger contrast separation between the sky and white cloud formations, as seen in the example at the top of the opposite page. Consequently, this group of optical filters is called black-and-white contrast filters.

Digital photographers, on the other hand, have tended more often to shoot in full color and then convert these images into monochrome using the electronic equivalents of colored contrast optical filters, available in various software programs. However, there has also been a trend towards setting the digital camera to record in the monochrome mode and using the optical filters. The use of software color filtration after grayscale conversion follows the same principles of filtration explained in the earlier part of the book for color photography; that is, to block or reduce a certain color requires the use of its complementary color. If an optical filter is used on the camera, then the filter does this by the process of subtractive filtration. It will allow its color to pass through while absorbing all others to some degree. The degree of absorption will depend on the strength or density of the colored material in the filter. The result is a change in the proportions of colors getting through.

So, if you want to darken the grayscale tone for a particular color, then a filter of its complimentary color should be used. As a result, less of the color in question gets through and it therefore appears as a darker shade of gray in the black-and-white image. If electronic filtration is used, the same principles apply, only the filtration takes

place electronically. The colorfully painted stairwell in Figure 9 (below) is an example of these two approaches.

I converted the original color capture (Figure 9, first image on the left) to grayscale in Photoshop (second image) using the Black & White default settings (Image > Adjustments > Black & White); you can see the dialog box for the Black & White option below the image. In the third image from the left, I used the in-camera monochrome mode and an Orange 21 optical filter (pictured below the image rendition). This filter rendered the originally blue entranceway frame much darker because of the complementary relationship between blue and orange, while making the yellow stairs lighter since orange contains so much of this warm yellow color. Note also that this complimentary relationship is reflected in the way the blue and yellow stand out from one another in the color original. The final frame (Figure 9, right) illustrates a reversal of the light/dark

tonal separation caused by the orange filter. To darken the yellow stairwell and lighten the blue outside wall, I made the following changes to the default setting in the Photoshop Black & White conversion control: I took the Red channel from 40% to 23%, the Yellow channel from 60% to 45%, and increase the Blue channel from 20% all the way up to 114%.

Not all examples of black-and-white contrast filtration are so dramatic. In fact, the ability to employ less extreme effects is one of the advantages of opting to go with software filtration. These programs can typically dial in a whole range of effects, from dramatic to subtle. These filters can be used to build slightly different tonality in areas of color that would otherwise translate into similar shades of gray. Sky areas can also benefit greatly from the use of contrast filters, and you can even use several different filters to achieve different degrees of darkening.

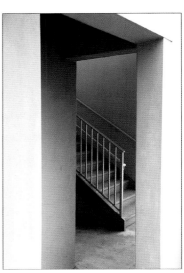

Figure 9

In these two photos of the former Coast Guard station on Cape Cod, Massachusetts, the effects of a Red 25 optical filter can be seen in the left frame, while in the right frame, I used a polarizing filter at maximum strength to darken the sky, plus a Nikon Soft #2 filter to add a bit of atmosphere. Remember that the intensity of the sky effect from the polarizer will depend on whether or not that section of the sky has polarized light, as explained on page 50.

Black-and-White Capture vs. Conversion

Which form of filtration is superior, optical or software, when dealing with grayscale images? There is no simple answer to this question. It very much depends on a number of variables. Here are some of the most important:

1 If you are going to use optical filters, then the digital camera has to be in monochrome mode. Many photographers are interested in both color and black-and-white renderings, however, preferring to decide later which will best represent the subject or scene. Shooting in monochrome mode eliminates the color option (unless you use a RAW+JPEG recording mode—see page 116).

2 A color capture contains more usable information for use later in the software grayscale conversion process, versus the more limited information recorded with a monochrome capture. Up until the last few years, this was one of the reasons why monochrome capture was really quite inferior to color conversion methods. However, newer camera modes have greatly improved the quality of monochrome capture. The question is, are the improvements enough to satisfy black-and-white photographers?

3 How much control do you want over the final results? Using optical filters limits the results to the strength of the filter, whereas software programs provide a much wider range of adjustment choices. A combination of both optical and software filtration is a good alternative; you can record the image with an optical filter and then tweak the result to your liking using software.

4 The biggest plus for shooting in monochrome mode is that the camera's LCD monitor will show you how colors are converting as you shoot. This is a real advantage, especially for photographers who do not have a lot of experience in black-and-white work and can quickly build up experience with this medium. Also, by seeing the results on the LCD monitor, you can decide if the scene has additional shooting possibilities. You may be motivated to experiment with different compositions, lenses, perspectives, etc.

5 Some cameras will have built-in color contrast filter effects that may also be used in lieu of optical filters to provide you with an instant view of the monochrome shooting results.

There are other variables that might be considered, but what all this really comes down to for many photographers is the desire to keep all the advantages available while avoiding the disadvantages. There is one approach that comes pretty close to this, and that is to set your D-SLR to record RAW+JPEG files with the camera in monochrome mode. This combination delivers a monochrome JPEG that will display on the LCD screen so you can see how colors are translating and how contrast filters (in-camera or optical) are changing the rendering. Again, this may very well lead to a further exploration of the scene and taking more exposures. Meanwhile, the RAW file is available if you want to do the color to monochrome conversion in the computer, taking advantage of the more complete controls that image-processing programs offer. If your camera has the RAW+JPEG option, this comes pretty close to having it all! Let's now consider some of the advantages of grayscale conversion from a color original using software by examining three programs: Tiffen Dfx, Adobe Photoshop and Nik Silver Efex Pro.

▶ Converting color images to monochrome in Tiffen Dfx software takes place in that program's open display. You can see a whole range of preset choices that can then be fine tuned by clicking on the Parameters tab in the lower right corner.

Note: Noise is usually more apparent at higher ISO settings in a grayscale capture as compared to a color capture. This is less noticeable when converting a high bit RAW file and more noticeable in an original JPEG capture, especially at higher compression ratios. Whether this is a visual problem for you, or not, will come down to your concept of the final image. Some avid high ISO shooters actually prefer to shoot in the monochrome mode, both for the black-and-white look and because the more granular noise that does result may be considered as more of an artistic element than the spotty, colored digital artifacts that appear in color capture noise. Do some experimenting with your own equipment and see what works best for you.

Tiffen Dfx: Tiffen Dfx grayscale conversion follows the same steps as the other Dfx filters we've discussed so far. Once the image is open in the program, preset choices are available to process the image through one of the following color channels: Red, Green, Blue, Orange, or Yellow. The basic conversion can then be refined by clicking on the Parameters tab (towards the bottom right of the screen in the image above, where you can access controls for brightness, contrast, and gamma. There are no specific listings for optical filter equivalents, such as Yellow 8, Orange 21, or Red 25. Rather, this program's grayscale conversion is based on a visual interpretation.

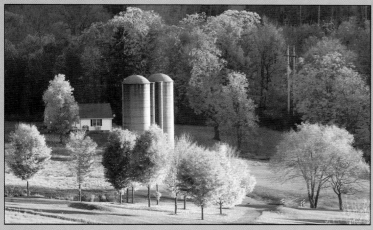

No Filter

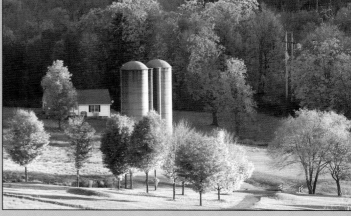

Green Filter

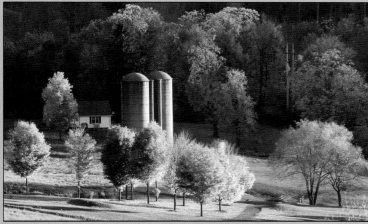

Orange Filter

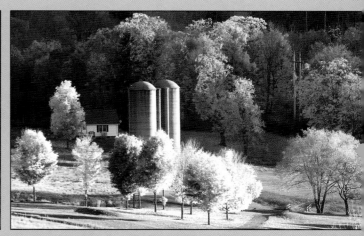

Red Filter

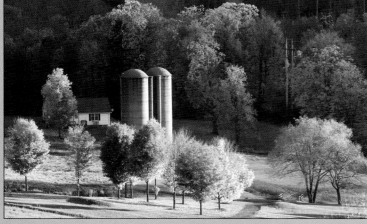

Yellow Filter

Blue Filter

I made grayscale conversions of the original color image (top left) by first selecting a color preset, as indicated below each rendition. Then, I used the Parameter controls in the program to tweak the preset conversions for the results seen here.

Adobe Photoshop: We have been concentrating on specialized filter programs throughout the book. However, the black-and-white filter conversion option in Adobe Photoshop (versions CS3 and later) is so easy to operate, and so effective, that I wanted to include it here.

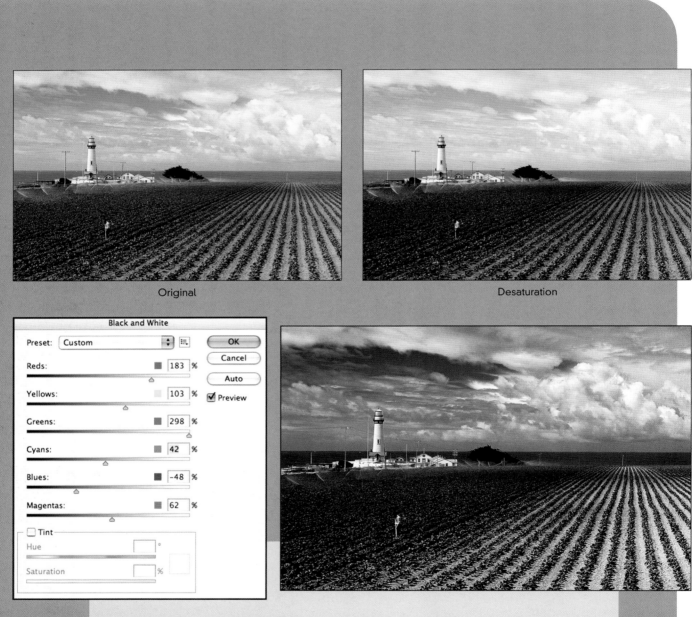

Photoshop's Black & White option (Image > Adjustments > Black & White) is an excellent conversion tool that provides the means for controlling how each color in a scene is converted to grayscale. Here, I converted the original color image (top left) to grayscale using this option, and you can see the results of the default setting at the top right. Compare that with my preferred result (lower right), in which I changed the separation of the gray tones to fit my preferences; you can see the slider adjustments in the dialog box at lower left.

Nik Silver Efex Pro: Nik Silver Efex Pro software is the most versatile program for achieving all types of black-and-white treatments. Not only will it directly convert a color image into black and white using a full range of color filters with the freedom to tweak these conversions, but it also has Nik's U Point technology for making local changes in contrast and tonality. These features make Silver Efex Pro a very powerful program.

As with Nik Color Efex, the dialogue box gives easy access to filter choices and the preview picture can be made quite large, as seen in Figure 9, at right. This program also allows you to select different film type emulations to apply as software filters—a fun set of options that we will cover in detail in the next chapter.

Figure 9

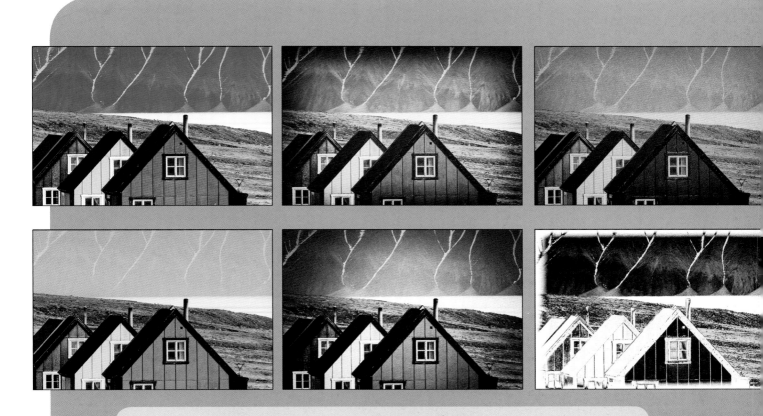

Nik Silver Efex Pro offers the simplicity of basic black-and-white conversion filter effects alongside more unique filtering options, such as those that emulate old film processes—top left, original color capture; top middle, Red filter + Antique Plate II; top right, Yellow filter + Tintype; bottom left, Yellow filter + Full Spectrum Inverse; bottom middle, Pin Hole Camera effect; bottom right, Antique Solarization.

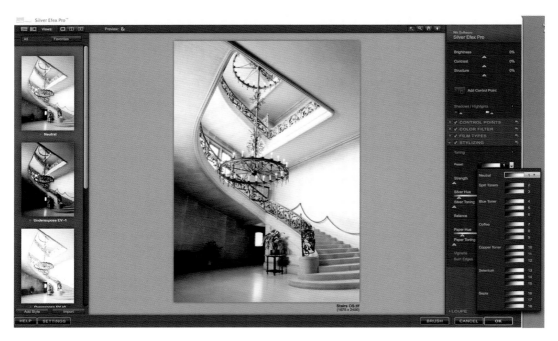

Nik Silver Efex software is designed specifically for converting color images to monochrome. Moreover, it is loaded with other features, such as applying different print tones and producing the look of different film types, as well as offering the control of its U-Point technology. It is a powerful program with an easy-to-use interface that has gained a high degree of acceptance among black-and-white digital photographers.

Toning Black-and-White Images

Photographers have a long history of adding color to black-and-white prints. This is a common option in many filter programs, and is fairly easy to accomplish. Some programs have preset tones that you can select from, while others allow you to set values on a sliding scale. Any software program that provides individual controls over the color balance of an image can produce an effect that emulates a black-and-white toned image.

Nik Silver Efex Pro offers the option of going from a full-color image directly to a toned black-and-white look (as illustrated in the image set on the previous page). Another program, called SilverFast, enables toning choices via a drop down menu along the right side of the program window (see the example, above). Selecting a specific color is a matter of personal preference. I favor Sepia tones and the cooler look of selenium, but there are many,

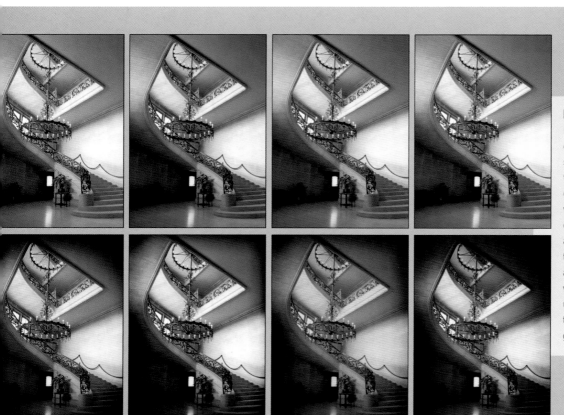

The variety of Silver Efex toning and other coloration effects can be seen in these multiple transformations of the original black-and-white version (top left). Such effects are just a click away, and serve to exemplify the power of using such a specialized program, versus the many steps usually required to achieve the same effects using a general imaging program.

many other choices, as seen in the image set to the lower left. Also, the technique of selectively coloring an image, much like hand-tinting a print, is always an option using Nik's U Point technology.

Some cameras, especially those aimed at the consumer market, will have the option to add tone effects in-camera, such as sepia or cyan tones. While this is a convenient way of producing a toned black-and-white image, it is a completely automatic change. One of the themes of this book is that creative photographers are always looking for ways to control an image to suit their own style. Controlling tone effects using image-processing programs is a more flexible, more creative solution.

Infrared Black-and-White Images

Converting an image to the look of black-and-white infrared (IR) using a software approach will often produce mixed results. Most photographers would agree that an original IR capture will yield the best results, but it is possible to achieve a reasonable representation using software, as seen in the example at the top right of this page.

The easy test to find out if your camera can record infrared images is to aim the IR beam of a TV remote control at the camera. If it records the beam, then the use of a visible-light-blocking optical IR filter will work with your camera. The most popular IR filters are the 87 and 89 series opaque red filters. The 87 filter completely cuts out the visible light spectrum and allows in a significant amount of infrared light, beginning at about 760 nanometers (nm). On the other hand, the 89b filter allows a small amount of visible light through at 690 nm for a slightly different look.

It is extremely important to make sure the IR filter completely covers the lens. Using a threaded round filter that precisely fits your lens mount is the best bet, but you can also hold an IR filter firmly over the lens if threading it on is not an option, as I did to produce the image to the right, bottom. Problems with light leaks can occur when using a flimsy gel IR filter in front of

I applied the Nik Silver Efex Pro Soft IR filter to the original color photo illustrated on page 118. This program not only produces good tonal transition, but it also includes a grain pattern reminiscent of IR black-and-white film.

I took this IR photo with an old Olympus C-2020 compact digital camera placed on a tripod and an 87 visible light blocking filter held against the lens.

the lens. If the fit is not tight and some visible light gets through, the image will have light streaks, or there will be bleached out white areas.

The very slow shutter speeds required when using a light-blocking filter make a tripod a necessity, and you have to pay particular attention to the presence of motion in the scene. Even if there does not seem to be any surface wind, be aware of how fast the clouds are

The movement in the palm trees on the right side of the picture is the result of the slow shutter speed necessary when using a visible light-blocking filter. I shot this image with a tripod-mounted compact camera that was capable of recording infrared light.

moving since they may blur due to higher atmospheric winds. It is also a good idea to use a cable release or set the camera's self-timer to prevent camera shake.

Digital camera sensors are sensitive to the near-infrared spectrum between 730–1200 nm but, starting in the early 2000s, camera manufacturers began installing IR blocking filters called "hot mirrors" that blocked IR light while allowing visible light to pass. The idea was to avoid the color-balancing problems that can arise when IR light interferes with visible light in the recorded image. Some of these filtration processes allow minimal infrared light through, but not all. In order to record IR light digitally, you either need to be in possession of a digital camera that allows at least some IR light through, or you can have your camera converted to record only in infrared. (Refer to page 121 for a method of checking whether or not your camera can record infrared light.)

Having a camera converted to IR recording means that all of the disadvantages of using an opaque light-blocking filter are nullified and you can take IR photographs with the full range of settings that were available to you for normal image capture. In other words, you can record IR images at handheld shutter speeds. This option has emerged as the preferred way to work among infrared photography aficionados. The one drawback is that a converted camera cannot be returned to its original state. Several companies now offer this conversion service, such as Life Pixel (www.lifepixel.com) and IRdigital.net (www.irdigital.net). Many more can be found by doing an Internet search using the key phrase: "infrared camera conversion."

The key to really impressive infrared photography is to shoot when there is plenty of infrared radiation present. Prime conditions occur in direct sunlight. Photographing when the sun is low can add three-dimensional shadow areas, but in digital infrared capture these shadow areas will record as solid black with no detail. Typically, shadow areas in a regular black-and-white photograph will have a degree of gradation from their darkest to lightest areas, but in IR photography, this gradation is a lot more compressed. Also note that without direct sunlight, such as on a cloudy or overcast day, the infrared effect is diminished, and the scene will take on a low-contrast, muddy appearance.

If you employ shadow areas carefully, there will be a sense of depth to the subjects in your IR photographs, as seen here. I waited until the sun's angle was low enough in the sky to cast half of each tree in a moderate shadow while producing strong ground shadows caused by the contours of the uneven ground. The weak IR light in the far background, however, rendered it dark, with a rather muddy level of contrast.

Finally, you will need to adjust the brightness and contrast levels of the captured file in the computer and desaturate any colorcast. IR images captured digitally have a very clean look and can be sharpened to a high degree in software. This is not quite like the look of infrared film capture, which tends to result in a soft, grainy rendering. Consequently, you might consider adding grain and even a soft filter effect if you are trying to emulate that traditional look and feel.

I shot this Cape Cod setting using a D-SLR camera converted to record only infrared light. The original capture (top) was very smooth. To emulate the appearance of IR film, I added grain and some shimmer effect using Tiffen Dfx software (bottom): Special Effects > Black & White > Grainy and HFX Diffusion > Pro-Mist #6.

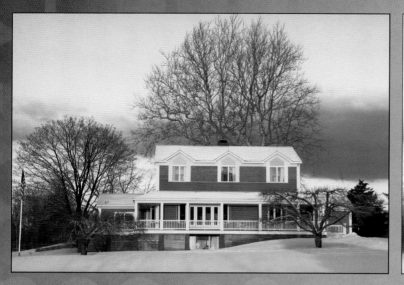

"Sharpness discloses every flaw;
a soft touch moves the soul."

5 Softening and Noise Reduction Techniques

IN THIS CHAPTER, we will examine three filtering approaches that all have to do with some aspect of sharpness. First, we will cover filter programs that are capable of producing a variety of soft effects. The overall purpose is to consider how using these types of soft effects can add something to the visual quality of the image. Second, we will focus on methods for giving digital images the look of film using filters in the Film Selection modules of Nik Color Efex. In the third and last section, we'll explore methods for dealing with digital camera noise, including what can be done during capture to lower the chances of noise becoming a problem and how noise-filtering software can be used as a post-capture remedy.

SHARP OR SOFT?

THE EVOLUTION OF PHOTOGRAPHY has been marked by a concern for equipment, materials, and techniques that will deliver the sharpest possible images. Undeniably, a large part of photography's heritage is the art of capturing moments of reality, as opposed to constructing reality as painters and other visual artists do. To that end, film and lens manufacturers have been willing partners in the quest for better and better overall image quality and greater resolving power. This quest has continued into the digital era.

Currently, there is some debate over whether or not lenses are now sharp enough for the best digital sensors. And yet, throughout most of photography's history, there have also been photographers who have sought print methods and materials that would produce softer, even painterly images. Consider, as an example, the Pictorialist school of the late 1800s and early 1900s, whose practitioners were influenced by the Impressionist style of painting. It was the Pictorialists who wanted to raise photography to the level of fine art by using, in part, softer, sometimes even ethereal interpretations of the world rather than the cold reality of a sharply focused image. Adherents preferred to be associated with the look and themes of fine art painters as opposed to the more realistic renderings of commercial and scientific photography.

Even in this modern era, there are many who have kept alive the tradition of the softer image. Certainly, portrait photographers as a group know full well that their clients are not happy to see every facial flaw captured with the same sharpness as the wildlife or landscape photographer strives to achieve. Portrait photographers are, however, not the exclusive users of the softer look. Indeed, many photographers use various soft filters to establish or reinforce mood in a landscape, while others use them to add a sense of mystery to their subject. And then there are times when reducing the degree of sharpness just seems to work best aesthetically for a certain subject in a particular type of light. All of these photographic techniques weigh in on the soft side of the sharpness question.

SOFTENING FILTER SOFTWARE

SOFTENING FILTER SOFTWARE

MY PERSONAL CAMERA KIT includes several optical filters in the soft category, but always in the back of my mind is the knowledge that there are also specialized software filter programs available today that can produce similar—and in some cases totally different—results. So, as standard practice, I always take some exposures without any filtration for possible use with one of these programs.

This original digital infrared capture was refined using a Tiffen Dfx glow filter from the program's Light category, plus the application of a strong Sepia filter toning from Nik's Silver Efex software.

While many imaging programs offer some form of soft filtration, a few programs are noteworthy in that they provide a range of filter choices designed to steer you toward more creative applications. These software filters can be applied in single or multiple applications, or even combined with other filters, optical or digital. In short, there are no strict rules when it comes to using soft filtration, only different directions shaped by the photographer's creative spirit. For example, I often use digital soft filters to produce very subtle effects that, nevertheless, result in pleasant changes compared to the unfiltered originals. I also use stronger versions to create a soft, ethereal feeling in a landscape scene, and even to mask (or at least mitigate) a sharply focused quality, such as a dominant texture, to allow other larger elements to be recorded with more prominence.

Some of the advantages in using software (as opposed to optical) filtration include the sheer variety of filters that can be applied in multiple steps, the different degrees available, and the ability to apply the filter in different localized areas of an image. This was the case in the example at left, in which I selectively added a Dfx glow filter after toning the image with a strong sepia treatment in Nik Silver Efex.

Indeed, unlike color correction and contrast adjustments that tend to have technical levels of correctness, soft filter effects have a range of expression that leave room for plenty of experimentation. With that as prologue, let's look at a cross section of software effects and how they may be used. Keep in mind that there are many other software programs out there offering soft filter effects, so be sure to do your own research and trials before committing to a specific product.

PixelGenius Diffusion Filters

Often, subtle softening effects can be used to just take the edge off of the sharpness in a picture without significantly altering the contrast level or making everything appear noticeably soft. This is typically appropriate for formal portraits or wedding pictures, as well as other forms of event photography, and even sometimes for causal snapshots of people. The idea here is to keep any facial flaws and blemishes to a minimum. These kinds of subtle applications are apparent if you compare the before and after versions. I use this filter approach routinely with any people picture that is going to be printed at 5 x 7 inches (12.7 x 17.8 cm) or larger, especially when direct or fill flash was used in the shot, as in the example below.

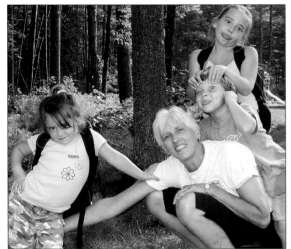
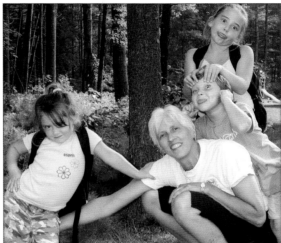

For this fun family portrait, I applied a PhotoKit #2 Diffusion software filter to optimize the look of the image by taking the edge off of the sharp appearance of the subjects.

The diffusion filters in strengths of 1 – 4 in the PixelGenius PhotoKit are very effective at producing subtle results. As explained earlier, PhotoKit is accessed from the Automate menu in Photoshop (File > Automate). The dialogue box that pops up will list the filters by strength (see Figure 1, right).

These diffusion filters give very clean and consistent results without introducing unwanted digital artifacts (such as bits of unwanted color information appearing as tiny colored specs in the image). They can also be applied more than once for a stronger effect. In my darkroom days, I liked the smooth almost creamy result that came from using a Zeiss Softar #1 or #2 camera filter under the enlarger and moving it up and down

Figure 1

during the exposure. The delicate, soft effect produced by this technique was accompanied by dark areas bleeding ever so slightly into light areas instead of the reverse when used on the camera. A similar look occurs when applying more than one application of the PhotoKit's Diffusion #4 filter, as seen in the last frame of the example below.

☑ The diffusion filter in Pixel Genius PhotoKit software is effective at taking the edge off of sharp images, as seen in the middle image compared to the image shot with no filter, on the left. When applied in multiple applications, as was done for the image on the right, this filter produces a soft bleed effect from darker to lighter areas.

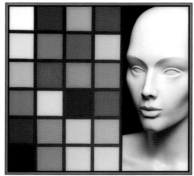
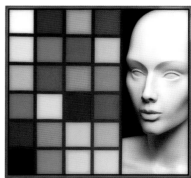

Diffusion Filter #2 Diffusion Filter #4 Diffusion Filter #4 (applied twice)

Gaussian Blur

Many photographers use the Gaussian Blur filter in their general imaging program to introduce a soft effect. This filter has an extensive range controlled by increasing the radius setting, and is capable of taking an image to the point of making it appear completely blurred and unrecognizable, as seen in the last frame of the example at right. I find this filter lacking in the more refined effects available in some of the other specialized programs featured in this chapter. The result is more like an out-of-focus picture. The one thing that Gaussian Blur can do effectively at low radius settings, however, is to mitigate print screen effects when photographing publications, such as books, magazines, and newspapers, as seen in the example on the opposite page.

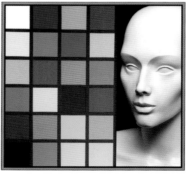
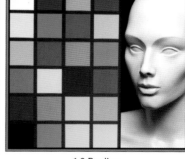

No Filter 1.0 Radius

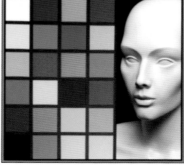

2.0 Radius 20 Radius

⌃ The first image in this set is the original, with no filter effects; the second is with a Gaussian Blur radius of 1.0; the third image is with a radius of 2.0; the fourth shows the radius all the way up at 20.0

Gaussian Blur filtration can be helpful at reducing the obvious pattern of a print screen when copying such half-tone materials as newspapers and books. The gold coin on the cover of my book on close-up photography (The Magic of Digital Close-Up Photography, top left) is shown in the top middle frame just as it was recorded, and in the top right frame with a small amount of Gaussian Blur added in Photoshop. The same treatment was given to the "M" on the printed card in the bottom row, with the bottom middle showing the original screen pattern and the bottom right illustrating the result of using a small amount of Gaussian Blur.

Figure 2

The Soft Filter in the Power Retouche program offers two separate controls: the soft filter effect from 1% – 100%, and levels of spread from 1 – 50. It also allows you to apply these selectively to light, midtone, and dark areas in the image.

Soft Filter by Power Retouche

For a stronger soft-focus effect, as well as more control over the effect's appearance, I will sometimes turn to the Soft Filter in Power Retouche (www.powerretouche.com), a filter that operates either as a single plug-in or as part of a suite of Power Retouche filters (see Figure 2, left). I use this filter mainly because of the dual control that the software offers; you can control not only the soft effect in percentages up to 100%, but you can also spread out of that effect on a scale from 1 to 50, thus increasing the result. This filter is rather unique because it allows you to design a number of specific effects by employing various combinations of the percentage of softness with the degree of how much the softness is spread out. If I want a very light soft effect, I keep the spread control low or at zero value. On the other hand, when working with strong highlights, a larger spread setting is likely to produce a desirable halo effect. Various combinations of the software's two controls can be seen in the example at the bottom of the opposite page.

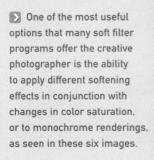

One of the most useful options that many soft filter programs offer the creative photographer is the ability to apply different softening effects in conjunction with changes in color saturation, or to monochrome renderings, as seen in these six images.

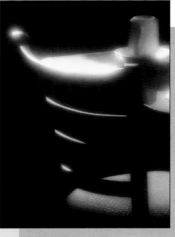
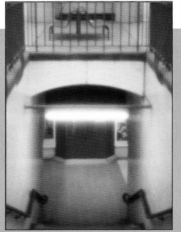

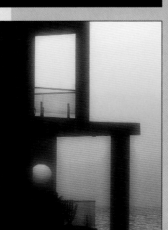

ScatterLight Lens by Andromeda

One more step up the ladder of filter software programs, is Andromeda's ScatterLight Lens (www.andromeda.com) program that offers many specific options for employing creative soft filter effects. It has four self-explanatory categories, each with its own set of controls for how strong the applied effects are.

This program has lots of filters to choose from for different applications, from landscape, to portrait, to special effects. Each selection can be modified using separate controls in the form of sliders with numeric readouts in the Expert mode, as shown in Figure 3, right. There is also a feature called My Presets that allows you to easily recall a particular combination of filter effects.

My favorite ScatterLight Lens filters are in the SoftFocus and Dream Optics categories, that add moderate to strong ethereal effects. I generally find that the default setting is pretty close to what I am looking for, although I often have to turn down any glow settings because of their tendency to blow out highlights. This program always seems to hold surprises when I start fooling with the controls. An adjustment of brightness and contrast afterwards in Photoshop is also sometimes needed.

Category	Effect
Dream Optics	dreamy highlights produced by the scattering of light
SoftFocus	softening portrait effects, from subtle to extreme
SoftDiffuser	diffusion or fog effects using different optical patterns
StarLight	multiple starlight effects

Figure 3

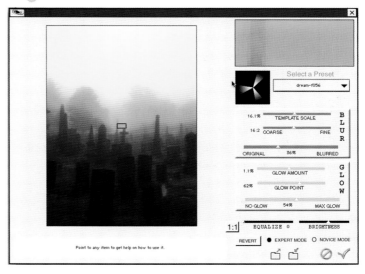

Here are three examples of filter effects from the Andromeda ScatterLight Lens program (left to right): No filter; Soft Focus > Landscape Halo; Fun Lenses > Liquifilter; Soft Diffuser > Fixed Fog.

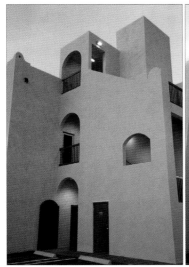
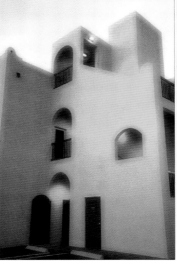

Tiffen Dfx

With the introduction of Tiffen Dfx standalone and plug-in software, photographers have gained an enormous palette of soft filter effects that emulate virtually all of Tiffen's optical soft, diffusion, fog, and similar filters. The program also contains very accurate counterparts to a full range of Light Balancing, Color Conversion, and Color Compensation filters, as well as other industry color standards. A separate window in the program display shows a magnified view, which is especially useful for gauging soft effects.

As with the program's color filter selections, the soft filters are available initially as presets with different densities. You simply choose a type of filter and select a preset density to immediately see a before/after comparison on the screen. Then, if you want to modify the results, clicking on Parameters replaces the preset selection list with a control menu, as seen to the right in the dialogue box illustration in Figure 4, below.

Dfx not only gives you the largest collection of soft filters to choose from, but also an extensive level of specific controls. You can even produce your own modified set of filters and recall them for future use. The layers option allows you to experiment with using more than one application or combining two or more different filter effects.

The Tiffen Dfx filters in the examples at right are only a small sampling of the enormous number of choices this program has to offer. Each filter illustrated was chosen from the preset menu in moderate strength, but all could have been modified in several different ways using the parameter menu if I had so desired.

Figure 4

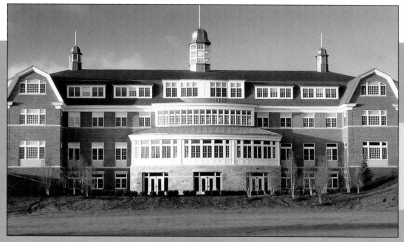

No Filter

Here is a comparison of some of the many filter treatments available in the Tiffen Dfx program.

Gold Diffusion FX 10

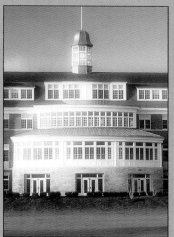

Cool Pro-Mist 10

Center Spot #1

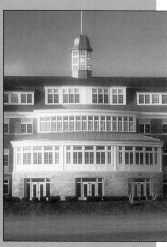

Warm Soft FX 5

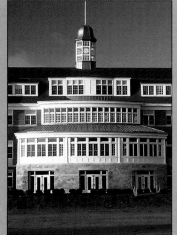

High Contrast 1

Low Contrast 4

Ultra Contrast 4

Bronze Glimmerglass 4

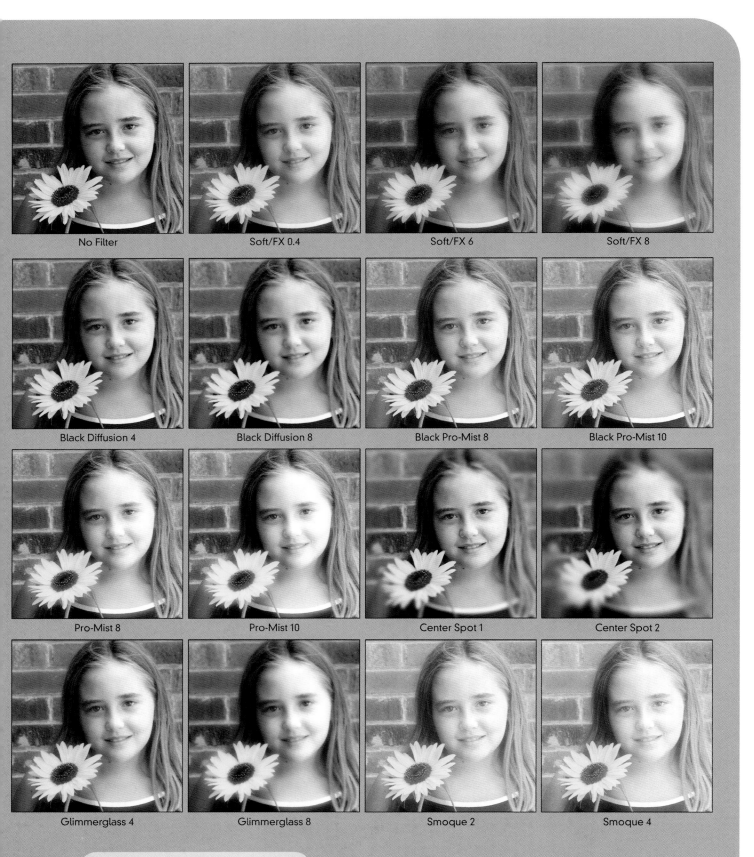

No Filter

Soft/FX 0.4

Soft/FX 6

Soft/FX 8

Black Diffusion 4

Black Diffusion 8

Black Pro-Mist 8

Black Pro-Mist 10

Pro-Mist 8

Pro-Mist 10

Center Spot 1

Center Spot 2

Glimmerglass 4

Glimmerglass 8

Smoque 2

Smoque 4

Tiffen has the largest selection of both optical and software softening filters. Here is a cross section for comparison.

I have settled on a number of different filters as my personal standards from the Dfx collection. For example, in the case of moderate, "mitigate-the-flaws" adjustments, I favor the Soft/FX filters and the Pro-Mist filters in weaker densities. I also like to experiment with the various filters in the program's Light set, especially the Halo category. Over the years, I have become familiar with many of Tiffen's optical filters, and this program provides me the opportunity to replicate—or at least emulate—those filter effects in a digital medium. Every time I start experimenting with a filter selection that is new to me, I discover something worth remembering, so I have taken to keeping notes just for this software. In short, Dfx is a virtual goldmine of soft filter effects, many of which you must experiment with beyond the preset selections using the specific controls offered in the Parameters section.

The use of shallow depth of field is very common in sports photography as a means of isolating players from crowds in the background, as seen here where I used a 300mm lens at its widest aperture of f/2.8.

Depth-of-Field and Motion Effects

In photography, depth of field is the area in front of and behind the point of focus that is acceptably sharp. As the aperture opening of the lens becomes larger, depth of field decreases. Conversely, as the lens aperture opening becomes smaller, the area that is in focus is larger, meaning the image will have greater depth of field. Mastering depth of field is a fundamental tool to employ in making great photos. It can significantly affect the relationship between a sharply focused subject and the background and foreground areas. Here's how it works.

A shallow depth of field around a sharply focused subject will visually isolate that subject, making it stand out clearly from the rest of the picture. A classic example is in sports photography, where you want to isolate the players from the spectators or the sidelines, as seen in the example above. The sports photographer will use long focal lengths to come in close to the players and the largest apertures to blur the background.

⬆ Landscape photographers generally strive to have the entire scene in focus by using small aperture settings such as f/16 and f/22 to maximize depth of field. This unifies the whole scene, as illustrated in the picture on the left, where the sharply focused shapes in the immediate foreground are repeated in the far background. Having everything in focus also allows for strong compositional elements, such as leading lines, to direct the eye into the picture, as with the foreground sand dune in the picture on the right.

The opposite result, in which the entire picture is in sharp focus, is the usual approach among landscape photographers. Their goal is to capture the whole scene in sharp focus while relying on compositional devices to give more or less importance to different parts of the scene. Instead of isolating subjects by having the background or foreground out of focus, they are often more interested in integrating all the elements, as seen in the examples above. While depth of field is controlled primarily at the time the picture is taken, it is possible to give the impression of a decrease in depth of field afterwards in the computer using such programs as Andromeda's Vari-Focus and FocalPoint from the onOne Software group. Let's take a look at what these programs are capable of.

Andromeda VariFocus: VariFocus software from Andromeda (www.andromeda.com) is one of those programs that you have to sit and play with for a while in order to appreciate. It does not really offer "one-click" operation, but its potential for unique results certainly makes it worth exploring. VariFocus is a program based on local effects. Basically, the program allows you to defocus portions of an image using different patterns to control where the effects occur, as displayed in the dialogue box below. This can produce a soft effect similar to using shallow depth of field as a way to isolate a subject. VariFocus can also go beyond simple depth-of-field defocusing to produce a more graphic result, as seen in the bottom example of the image set at right..

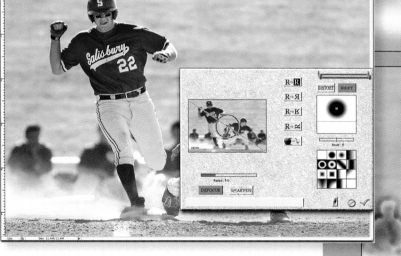

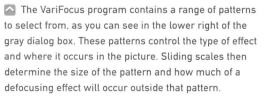

The VariFocus program contains a range of patterns to select from, as you can see in the lower right of the gray dialog box. These patterns control the type of effect and where it occurs in the picture. Sliding scales then determine the size of the pattern and how much of a defocusing effect will occur outside that pattern.

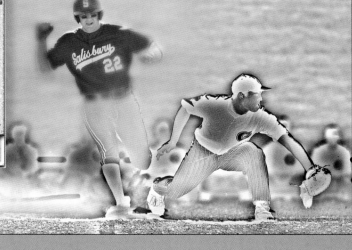

Some of the options for introducing out-of-focus areas using Andromeda's VariFocus software can be seen here, where the shallow depth of field created by using an f/4.0 aperture in the top image has been increased using a selective VariFocus blur pattern in the middle frame, thus increasing the attention on the base runner. In the bottom frame, a type of color solarization filter was applied for a special effect rendering to demonstrate some of this program's other capabilities.

onOne FocalPoint: The Portland, Oregon based onOne Software group (www.onOneSoftware.com) has been around since 2005 and is headed by founder, Craig Keudell, the former CEO of Extensis. FocalPoint is a powerful program that allows you to selectively change the sharpness of any portion of the picture, producing everything from areas of selective focus to a range of blurs, streaks, and vignette effects. This is carried out by using a controller called the FocusBug that overlays the image (see Figure 5, below). This tool also lets you set the plane of focus, much like a view camera does, as well as providing a selection of different effects around the sharply focused subject, as seen in the bottom right of the image set below.

Figure 5

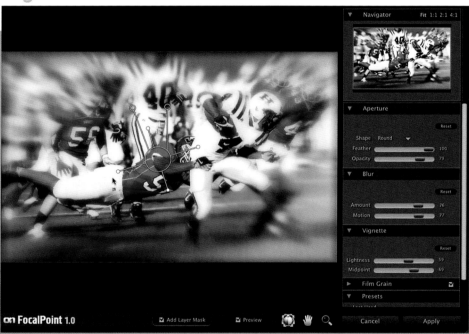

◄ onOne Software's Focal Point program is especially good at introducing blur and streak effects to help isolate and draw attention to a subject in a crowd, as in these before and after football pictures. The program uses a unique selection device called the FocusBug to control where the effects will be applied. In this case, I have set the FocusBug to include just the two players in the immediate foreground, then I applied a combination of a blur and streak patterns projecting outward from them to exaggerate the illusion of motion.

FILTERING FOR THE LOOK OF FILM

FILM AND DIGITAL PHOTOGRAPHERS OFTEN ARGUE over the differences between the look of their respective mediums. There is certainly a wide variety to the look of individual films due to the proprietary grain structures and colors used in their emulsion chemistries. Digital capture, on the other hand, while showing some differences between camera models, tends to have a noticeably cleaner and more uniform appearance. So, in response to the continued desire to achieve the look and feel of traditional film effects, software designers have attempted to provide digital photographers with ways of emulating the appearance of various films. The easiest way to do this is to add grain. Many general imaging programs have a grain filter in their texture category, or a noise filter that can be used to produce the look of grain.

Here, I used Photoshop's Noise filter to achieve a gritty, high-speed film look.

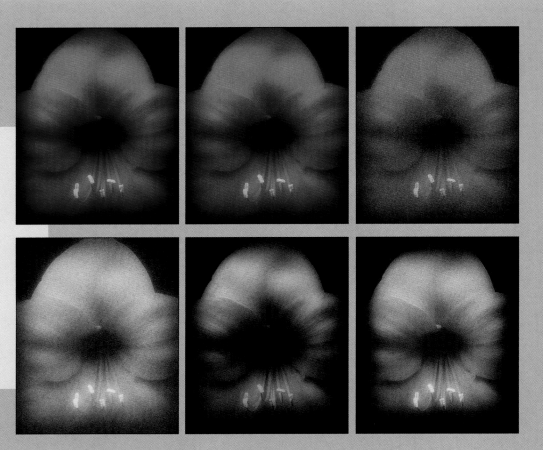

> ❯ After converting the red flower to black and white in Silver Efex for the examples in the bottom row, I used Color Efex to transform both the color and monochrome renditions simply by altering the look of the grain using the program's controls for Grain Size, Highlight Grain, Midtone Grain, Shadow Grain, and Grain Saturation. Needless to say, the possible combinations for different results are quite extensive.

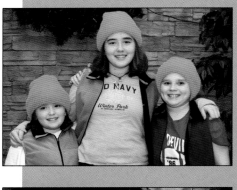
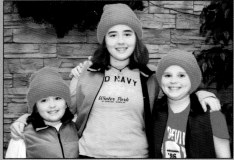
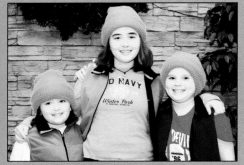

> ▲ I ran this family snapshot through the Nik Color Efex Film Effects (top row) and Nik Silver Efex (bottom row) to emulate the following films and processes (left to right): On the top row is the original capture followed by Fujichrome Velvia 100, then Cross-Processing #T04; on the bottom row, I used Kodak Panatomic-X ISO 32, Push Processing N +3, and Kodak TMax P3200.

Many photographers feel that just adding grain often looks like a faked effect without the peculiar grain pattern of certain film stocks, such as Kodak's Tri-X or a slide film like Fuji Provia 400x. In their view, there is more to consider than just the presence of grain—specifically, the way different films will also render a scene in terms of color and contrast. Film stocks such as Kodachrome, Ektachrome, and Fujichrome have different color agents and levels of contrast that record colors differently. Furthermore, within each of these film types are choices in ISO speed choices. For example, Fujichrome's Provia is available in ISO 100 and ISO 400 versions. In general, the faster the film, the lower the saturation of the colors and the more obvious the grain.

Then there is the practice by some photographers of having their film processed differently, such as overexposing the film by one stop and then having the lab push the development to compensate. A more unusual departure is the cross processing of color film. That is, processing color slide film in chemicals for print films, or vice versa. In black and white, there is a rough, high-contrast look that comes with push processing the film as much as three stops. The look produced by these procedures holds a certain attraction for some digital photographers.

In response to this more involved and sophisticated consideration of film's characteristics, Nik Software created an extensive number of film replication filters that can be applied to an original digital image in their Color Efex and Silver Efex programs. Some of these selections even offer the specific look of color or black-and-white film stocks that are no longer available. This is a bit ironic since the remarkable growth of digital photography was one of the major reasons for the demise of these films!

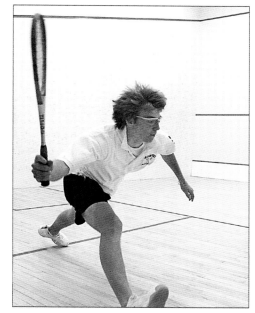

Digital noise has several causes and takes on different forms. The key to determining whether or not the level of noise is unacceptable is to examine the image at the size of the final print. In the picture on the left, the size of the image does not make the appearance of noise prohibitive to an acceptable image. In the magnified version of the photo, however (right), you can see that the noise level is unacceptable, so this image could not be enlarged to that point for print or display.

DEALING WITH DIGITAL NOISE

ALL DIGITAL RECORDINGS contain a variety of unwanted signals collectively known as noise. These non-image forming signals are most easily seen in smooth, evenly colored areas such as blue skies or the surface of skin, as seen in the example above. Typically, noise appears as random, colored specks in color photos, or as a granular texture that many equate with film grain. It may also take the form of blotches or band-like irregularities. When digital noise is excessive, it detracts from the quality of the image by breaking up the purity of colors and textures, as well as interfering with the crisp appearance of sharply focused subject matter. It may even dilute contrast.

Noise reaches a point of distraction when it becomes conspicuous to the viewer. For example, the noise level in a 4 x 6-inch (10.16 x 15.24 cm) print may not be obvious, but when that same print is blown up to a larger print size, or enlarged on a screen with a digital projector, the digital noise artifacts can detract from the clarity of the picture. So, a key point in evaluating what amount of noise is acceptable in a given shot is the size at which it will be displayed.

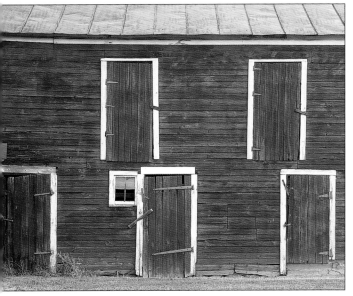

The addition of a grain pattern, along with a toner effect like sepia, can easily convey the impression of an old photograph, as seen in this before and after example of an old barn.

In black-and-white images, noise most often occurs as a grain-like pattern. Sometimes, the gritty look of noise can add to an image, such as when it contributes to the irregularities of textured surfaces. Noise can also give a grainy look to help achieve the appearance of an old photograph, such as in the photo above. These situations aside, however, digital noise is generally an unwanted image element.

Can filters remove digital noise? The truest answer is no, they can't remove it, but they can mask some of it. For example, using a strong soft filter, whether optical or digital, can blur the detail structure of noise so that it is less evident. If, however, the noise is strongly colored, using these filters may not be especially effective. A much better approach to dealing with noise is always to keep it to a minimum at the time the picture is taken.

Preventing Noise at the Point of Capture

The interest digital photographers have in wanting to minimizing noise in their images is reflected in the importance given to noise test results in new camera reviews. The final evaluation of noise testing is usually summarized in general categories, such as extremely low, moderate, high, or unacceptable. These evaluations are based, in part, on the measurement of the camera's signal-to-noise ratio, abbreviated as "S/N." The S represents the strength of the image-forming signal and the N represents the amount of noise. The higher the proportion of noise in the mix, the greater the chance that it will interfere with the quality of the image. The newest cameras, especially those in the professional class, are now producing low to moderately low noise with ISO ratings as high as 3200 and even higher in a few select pro models.

Digital noise is actually a catchall term for a number of different unwanted signals coming from various sources. An Internet search of the phrase "digital noise in photography" will bring up many technical articles for those of you who would like to delve into the physics of this subject. Most photographers, however, are concerned with practical answers to two main questions: What can I do to keep noise to a minimum when taking the picture? How can it be filtered out in the computer? Regarding conditions at the point of capture, there are three main situations that have the potential to produce greater noise levels: high ISO settings, long exposures, and underexposure.

Noise and High ISO: The prominence of noise at higher ISO settings has to do with the increase in sensitivity to light. Higher ISO functions are achieved in camera by amplifying the image-forming signal above the base ISO level, and that also means amplifying the noise. As a generalization, noise usually becomes a significant problem with point-and-shoot camera models at about ISO 800, or even ISO 400 with some models. With consumer level D-SLRs, that number is closer to ISO 1000, or perhaps even 1600. However, the reason for using a high ISO setting is to deal with low-light conditions, which is a second potential source for more noise due to a high degree of shadow areas where the light intensity is very weak. So, in many cases, some noise in unavoidable.

Long Exposures and Photosite Size: In low light, the additional exposure time needed to collect enough light to form the picture means that more noise signals will be recorded. This is true at any ISO setting. In addition, long exposures cause a heat buildup on the sensor that can produce a type of noise called dark current, or thermal noise. Many D-SLRs include a selectable noise reduction setting intended for long exposures. How effective this feature is will depend on the camera model. My experience has been that specialized noise filtering software will do a better job.

The size of the individual photosites is another contributing factor. The larger the photo site, the greater the number of light photons it can capture. This, in turn, means a lower proportion of noise signals. Small point-and-shoot cameras have tiny photosites on small sensors but with high megapixels counts, and that is one of the main reasons for their higher noise levels compared to D-SLRs with larger photosites.

Underexposure: This third contributor to noise, underexposure, requires us to pause and consider how exposure affects the final image. Pictures with a noticeable level of noise are sometimes the result of the way digital photographers set their exposure. Digital cameras record the light in a linear fashion. That is,

every increase in exposure produces a proportionate increase in brightness. If you give a scene just a little too much exposure, the highlights will fall beyond the camera's exposure latitude and appear "blown out," as bright white or very weakly colored areas that lack detail. Likewise, not enough exposure will mean the sudden loss of detail in shadow areas, producing "black holes." So, the idea is to capture the most important image-forming light within the exposure latitude of the camera.

Overexposure of highlights tends to be more visually detrimental to an image than loss of detail in shadows, so it is usually most important to preserve highlight areas. For this reason, many photographers tend to slightly underexpose a scene to make sure they do not blow out the highlights. The problem with this approach is that more of the scene is being pushed down the recording scale toward the shadow areas, and that increases the risk of noise. Even setting a correct exposure may mean that you are not maximizing the exposure to avoid as much noise as possible.

Enter the "exposure-to-the-right" strategy, which is intended to maximize the capture of highlights while keeping shadow areas "out of the mud," so to speak, where proportionally higher levels of noise lurk. The recommendation here is to increase exposure as far as possible to the right, as shown on the camera's histogram, without overexposing the highlights. This means that shadow areas have been recorded higher on the exposure scale with less noise. Then, in the computer, reset the exposure to correct levels. This approach is best carried out with RAW files since adjustments in exposure can be made with far less danger of cutting into image quality than is the case with JPEGs. RAW files have a high bit capacity (between 10 – 14 bits, depending on the camera) while JPEG files can only hold up to 8 bits of color information. The higher the bit capture, the more room there is for non-destructive editing in the computer. There are many more implications to using this approach for minimizing noise, and I encourage you to do some of your own research into this technique. Searching the Internet with the phrase "expose to the right" would be a good place to start for more complete information.

Noise-Filtering Programs

In the last few years, a number of very effective noise-filtering programs have become available, of which four seem to be very popular among photographers: Neat Image (www.neatimage.com), PictureCode's Noise Ninja (www.picturecode.com), Nik Software's Dfine (www.niksoftware.com), and Imagenomic's Noiseware (www.imagenomic.com). In addition to reducing noise in digital images, they can also reduce the appearance of grain in scanned film images.

Before you begin working with any noise-filter program, it is a good idea to look closely at the images you intend to work with. I usually do a little analysis trying to spot problem areas, such as speckling and grain-like textures, by zooming in on the image for a closer look. As pointed out earlier, sometimes noise problems do not become apparent until the file is enlarged, so I will check at 50% to 100% of the file size to get an idea of what will happen when the image is enlarged. This brings up two issues: whether to remove noise before or after enlarging for final print size, and whether to sharpen the image before or after removing noise. As to the first issue, I prefer to apply any necessary noise filtering before enlarging to the final image size

so as not to amplify any existing problems. When it comes to sharpening, the general rule I follow is that it should be the very last step after enlargement and noise reduction.

It is important to be aware of the power of these noise-filter programs, not only for removing noise, but also to reduce details in the image. This is the basic trade-off with noise filtering. Some photographers prefer a very smooth look, while others like to preserve some irregularities in the final image. This is a matter of personal preference, but few photographers will want to take the noise reduction process to the extreme of making the subject appear wax-like, as seen in the example below.

All four of the noise-filtering programs I mentioned offer two basic approaches; procedures are carried out either using an automatic mode or through a series of

Noise filtration programs can be very effective at reducing noise and other unwanted artifacts, but they can also be over used, as demonstrated here. Excessive noise filtration applied to the photograph on the right has robbed the original picture (left) of important details, such as the streaks of blowing snow, while making the building appear wax-like.

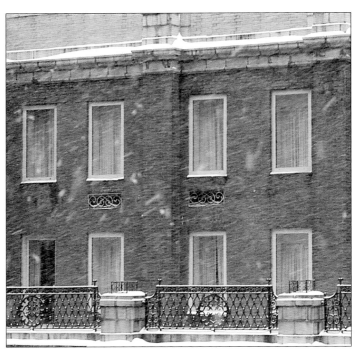

step-by-step manual choices. The manual approach means more time spent working on the image, but the results might be more to your liking. Having said that, designers have told me that they make every effort to design their software so that it works very effectively in auto mode. Truth be told, many photographers, myself included, use the automatic mode routinely.

The strategy for working in both approaches is the same: the program will first analyze the noise in the image, then you can either manually apply a noise-reduction profile that removes or mitigates the noise level, or you can have the program apply it for you. The noise-reduction profiles are specific to the camera model that took the picture, or the scanner that scanned the film, and can be saved for future use. Camera profiles are not only specific to a certain camera model, but to the ISO setting used, since different ISO settings will produce different levels of noise as the image signal is amplified more and more.

The effectiveness of noise-reduction programs depends on these profiles. As a result, noise reduction software programs make an effort to have camera profiles available, as well as providing the means for you to make your own. Each program uses a different way of providing profiles. With Neat Image, for example, users have access to profiles built by other users listed by camera model and ISO setting on the Neat Image website. Noise Ninja supplies an electronic version of a color chart for you to print and then photograph at different ISO settings. This is then opened in the software to serve as the reference file for building a profile for each ISO setting. Nik's Dfine and Imagenomic Noiseware Professional both build profiles on the fly as the image is processed. These can then be saved for future use.

Which Program to Use: A visit to various photography chat rooms on the subject of noise-filtering software will quickly reveal strong preferences for a specific program. These positions are not only shaped by people's experiences with a certain program, but also by the photographer's main subject area and workflow. For example, consider a sports shooter who has hundreds of images to process daily containing noise picked up at high ISO settings under artificial arena lighting. Now, compare these needs to a landscape photographer with much fewer images shot at lower ISO ratings under a variety of different natural light conditions. Obviously, for the sport shooter, the availability of batch processing, plus a program that filters noise quickly, is important, whereas the landscape photographer may be more interested in how specific the program can be in terms of local noise filtering. Such diversity, plus the individual preferences for certain looks, undoubtedly drives the different opinions heard in chat room discussions.

For my own clarification, I decided to ask an expert, Janice Wendt of Nik Software, to see what she could do to fix up one of my noisy images shot in low light. Janice has an extensive background as a professional photographer and retoucher, and she travels around demonstrating Nik products, including Dfine. The results seen in the images on the following page were quite revealing.

She not only used Dfine, but also other Nik software such as Viveza (for color corrections), and applied local improvements in addition to global corrections. I tried to duplicate her results exactly but was not quite able to. This is a lesson for anyone who wants to maximize results with these and any other software program. Easier programs, like PhotoKit Color, that rely entirely on preset changes, require only that we spot a need for change, apply a preset, and see if we like the results. With more complex operations, such as those needed for the kinds of corrective filtration in noise reduction and color correction, we really need to learn how to use the program in order to make the most of it. That means putting in the time, reading the manual, and dealing with the occasional, but inevitable, frustrations that will occur.

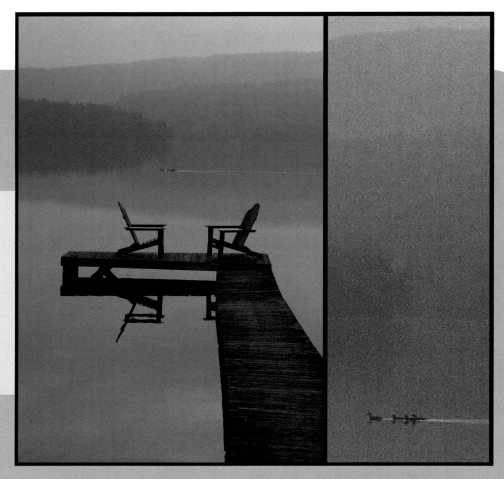

I asked Nik Multimedia software expert, Janice Wendt, to remove the noise from my lake scene image set, taken at dusk (top). She not only removed the unwanted artifacts, but also improved the color and appropriately sharpened the image, as seen in the final result (bottom).

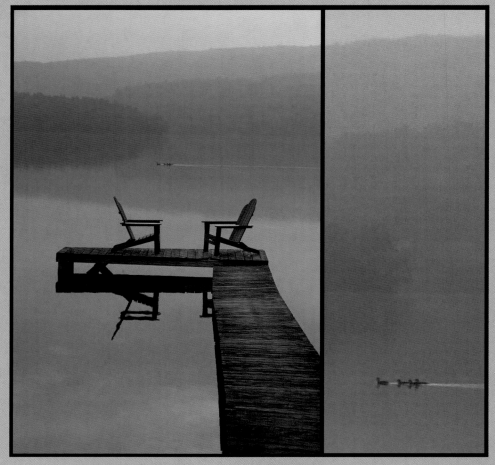

MY THREE-PART APPROACH

MY THREE PART APPROACH

IT CAN BE OVERWHELMING to consider all the software choices available in today's market, with new ones appearing all the time, to say nothing of frequent upgrades. In the end, however, the old photographic adage still holds true: Success is a function of putting in the time and effort to learn one's craft. Thus, I have found that the best way of dealing with all these choices is to follow a three-part approach that has allowed me to build up experiences with a handful of programs that serve my specific needs. It takes time, but it has been worth it. I am not suggesting that you use the specific programs that I do, but I do recommend this procedure.

First, I do what is needed to make the image technically sound using software I am very familiar with and have used for several years. This includes Adobe Photoshop, Pixel Genius PhotoKit and PhotoKit Color, Color Mechanic Pro, Nik Viveza and, if necessary, a noise filtering program. Only then do I consider the next phase, in which I take the time to think about what potential is still locked within the image. Here is where I mainly turn to Tiffen Dfx and Nik's two Efex programs (Color Efex Pro and Silver Efex Pro), looking to exploit potential that I may have been aware of when the picture was taken, or that became apparent as I looked at the image on the computer screen. Once I have an idea or a concept, the process of creative filtration can then begin with these programs.

I would say that, in the majority of cases, this is where the process ends because I am pleased with the results. If not, I may then go to stage three, in which I try out new treatments, really experimenting just to see what will happen to the image. This last phase is more of a freewheeling approach, and the success rate is a lot lower. On the other hand, I am sometimes surprised by a pleasing result, and that is how I build up new treatments, or creative avenues, as I like to call them. In the end, this third phase usually tells me something about the picture that I was not aware of initially, and that makes me a better photographer. Plus, the next time I go out with my camera, whether for my personal work or on an assignment, I have a new idea or two to try out, and that is called personal growth.

"We see life filtered through experiences that change us a little each day."

6 A Personal Portfolio

THIS LAST SECTION CONTAINS A SERIES OF IMAGES OF DIFFERENT SUBJECTS PRESENTED MUCH LIKE ONE WOULD DO IN A FORMAL PORTFOLIO, OR AS PART OF AN EXHIBITION. Many of them are framed with a colored border that is in chromatic harmony with the colors in the picture. This is something I often do in exhibits. All of these examples demonstrate how the different optical and software filtration techniques discussed in the previous five chapters play an important role in the finished picture.

After briefly explaining the strategy behind each image, I then offer a list of the main procedures used to create it. I do not touch on every single minor adjustment I made to each image, but rather I detail the most important applications used to make the photograph. For the most part, these images from my personal work are ones where I have incorporated a great deal of experimentation. My commercial assignments often are more defined in purpose and theme, but this is a show of my personal imaging preferences and creativity.

Portfolio 1

ENVIRONMENTAL FILTRATION

Successful use of natural filtration comes down to seeking out the conditions that produce it and developing a composition that will benefit from it. In the opening chapter, I pointed out how light can be significantly modified in terms of its intensity, contrast, and color as a result of interacting with the physical environment. This first portfolio section contains examples of how two such naturally occurring conditions can produce very interesting photographic opportunities. Specifically, fog and the warm colors of sunset or sunrise.

Portfolio 2

DEATH VALLEY AT NIGHT

Needless to say, I have taken lots of images over the years, but a busy schedule has kept me from returning to record a different phase of Death Valley's iconic locations: a portfolio of images all taken well before sunrise, when there is no hint of the orange-red coloration that immediately precedes the sun peaking over the horizon. This is basically the cool blue period, with just a hint of the magenta phase. So, I decided to see if I could emulate the look of this blue period using software on images originally taken in daylight. The example shown here is of the mud flats in the Race Track area of the valley.

Portfolio 3

SPORTS PHOTOGRAPHY AS ART

I have photographed professional and amateur sports at different times in my career, always striving to capture players in dynamic positions and in sharp focus, but I also like alternative ways of portraying the action. One of my favorite techniques is to emphasize the feeling of movement. I also love catching the laser-like concentration of the players, as exemplified by the two images in this section. In a sense, there are two contradictory concepts at work here, since fast shutter speeds actually freeze movement. So, I applied certain filter techniques to allow all four things (dynamic positions, sharpness, concentration, and motion) to coexist in the same picture.

Portfolio 4

MONOCHROME IMAGES

As we covered earlier in the book, removing color from an image reduces everything down to the most basic visual elements as represented by shades of gray (or shades of one color in the case of a toned grayscale image). I tend to convert a picture to monochrome when I feel that the main visual elements are very strong and I want to concentrate on their basic characteristics. In addition, since for so much of its history photography was a monochrome medium, and often sepia toned, there is a tendency to think of any sepia image as something from the past. I employed these imaging ideas when creating the photos in this section.

ENVIRONMENTAL FILTRATION

Fog

I have always been struck by how colored subjects in a foggy scene can appear so much more impressive when you enhance key colors that were muted by the fog. This is particularly effective when the colors are complementary to the blue veil typical of a fog setting. In this forest example, my attention was drawn to the red and orange colored leaves on the foreground tree, as well as to the rich color of the green grass. The original capture, however, hardly showed these colors (see below). This is yet another example of how the human mind tends to focus on, and give more importance to, certain details in a scene as compared to what the camera actually records. I created the desired effect in the computer as follows:

The camera's white balance was set to Daylight capture with hopes of creating a blue colorcast, but the result looked rather drab. So, I lowered the Kelvin temperature by about 400° using RAW file processing software.

I then adjusted the overall contrast in Photoshop using the Curves tool.

Next, I used the Indian Summer filter from Nik Color Efex to selectively enhance the warm colors (Stylized Filters > Indian Summer > Color Method #3 > 50%). Unexpectedly, this also brought out a lot of warm coloration in the ground cover that I was not aware of when the picture was taken.

The last step was to raise the saturation of the green grass in Photoshop (Image > Adjustments > Hue/Saturation > Green > 10%).

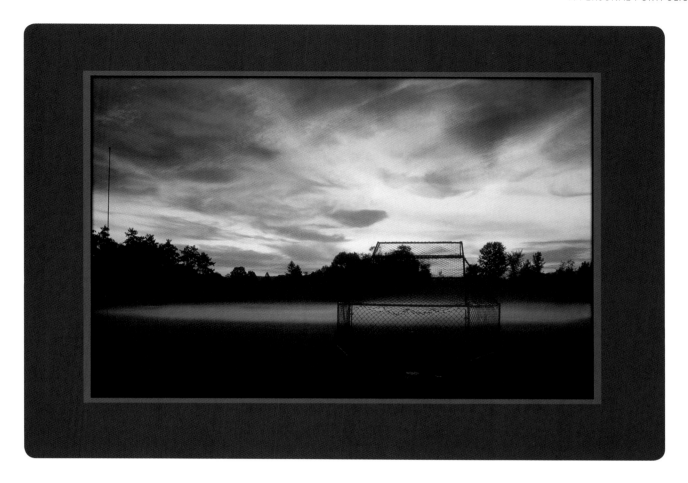

Baseball Field

Believe it or not, I almost missed seeing this spectacular shot. The sky area was behind me and I only saw it as a flash of color in my rear view mirror as I pulled into a local coffee shop. I quickly positioned myself across the street, just outside the field, and began clicking away with different compositions before the colors faded. To create the final image:

I started with an exposure of f/5.6 at 1/125 second and ISO 400 with my camera mounted on a tripod and the zoom lens set to 24mm (seen in the original capture at left). The composition was simple enough, with the outline of the baseball backstop and the strip of fog in the dark middle ground contrasted with the stunning colors and patterns in the sky.

I slightly burned in the top of the sky area with one application of the Burn Tone tool in Pixel Genius PhotoKit Color. This tool gives a choice of burning in any of the sides of an image frame with an effect like a graduated neutral density filter. I chose this neutral graduated effect rather then a blue graduated filter because the blue color in the sky was certainly strong enough and only needed a slight increase in density. I have been asked numerous times whether the sky was colored in Photoshop, but the colors needed no other adjustment.

Using Photoshop, I selected the fog in the foreground with the Eyedropper tool, and brightened this area a bit with the Curves tool and then ran the final image through Imagenomic's Noiseware Professional at the Weak Noise level before final sharpening.

ENVIRONMENTAL FILTRATION

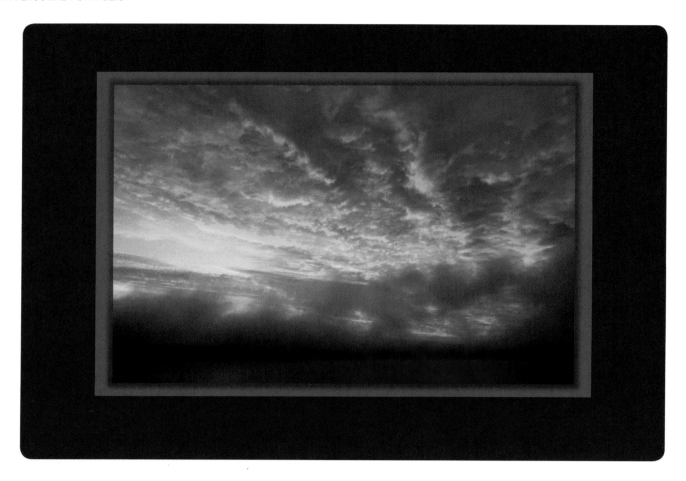

Clouds Over the Lake

I took this shot with my camera on a tripod off of my lakefront property in New England. During the fall, I frequently set up there very early in the morning in hopes of catching fog coming off the water along with some interesting cloud patterns with color. This particular morning, I was lucky to get a nice layer of surface fog and really good cloud patterns and color.

For my original capture (left), I used a 20mm wide-angle lens and tipped the camera up to cause the clouds to appear fanned out, and therefore more prominent as the key compositional element.

I also used an optical one-stop graduated ND filter positioned to darken down about 30% of the sky to give the colors more density. As mentioned earlier in the book, I take many pictures with a graduated ND filter at different positions in the filter holder, making a final choice about which worked best later in the computer.

I made some minor changes in contrast using Photoshop's RAW file software to darken the sky a bit, but the level of color saturation in the final image is basically just as it appeared that morning.

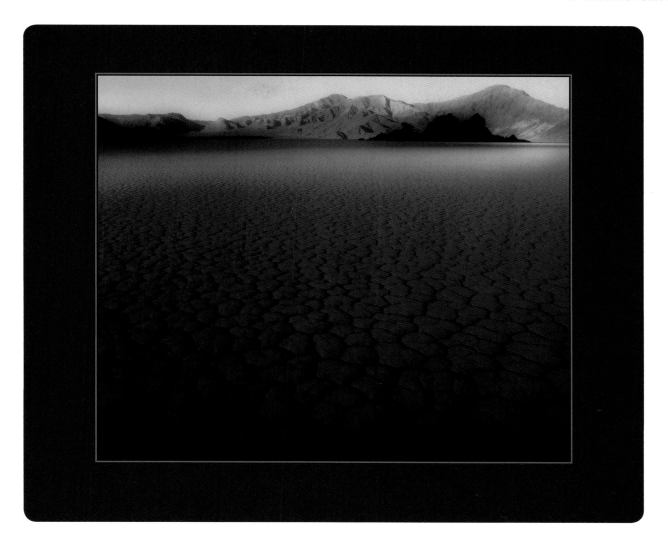

Salt Flats

This location in Death Valley is famous for stones that seem to mysteriously move across the desert floor leaving tracks. For my composition, I chose to emphasize the expanse of the location, creating a nighttime treatment to convey the mysteriousness of the place.

After trying different night filter approaches, I found that it was necessary to first raise the general brightness level of the original (left). This gave me a better rendering of what would otherwise be a rather dark final image.

The software that gave the look I wanted was Tiffen Dfx's Day for Night filter (Special Effects > Day for Night #5) also available as an optical glass filter.

I then added a Dfx Pink Graduated filter to the sky to give just a hint of the coming magenta period before the sunrise.

Next I created a significant darkening of the foreground area using three applications of the Burn Tone tool in Pixel Genius' PhotoKit Color.

As a final treatment, I wanted to mimic the soft nature of dawn light, so I used the Andromeda's Scatterlight soft filter.

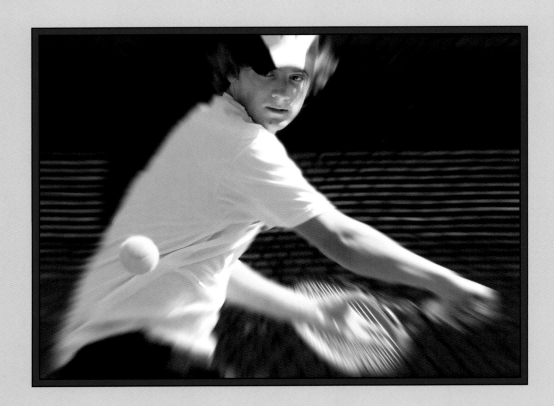

Tennis Action Shot

In the case of this tennis player, I had to use a very fast shutter speed in order to freeze the action. While this fast shutter speed also allowed me to capture the pure concentration on the players face, it robbed the picture of any sense of motion, which is so much a part of tennis. So, I turned to the use of some motion filter techniques, as described below.

I achieved the almost heads-on framing in my original capture (left) with a zoom lens set at 350mm exposed at f/6.3 and 1/1000 second.

In the computer, I kept the ball and face of the player in sharp focus to maintain the element of concentration. Then, to give a sense of movement and further reinforce the concentrated gaze of the player, I applied two applications of the Photoshop Zoom effect (Filter > Blur > Radial Blur > Zoom). To make these two applications, I first outlined the area of the player that is in sharp focus with the lasso tool and then used the Select Inverse function so that the zoom effect would be applied only to the area around the player. The first zoom application was at value 8 and a second was at 15. Between the two applications, I reselected and enlarged the area around the player so that the strong zoom lines were further away from him.

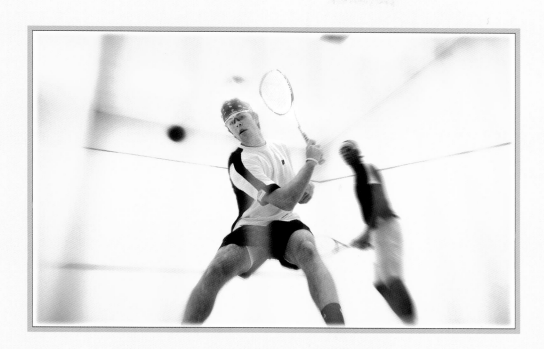

Squash Action Shot

Since squash matches take place in a relatively small, glass-fronted court, the distance over which the players move is much smaller as compared to tennis. In addition, tennis requires the use of telephotos from positions way off the court, which has a tendency to compress subjects and backgrounds together. On the other hand, squash gives the photographer the advantage of being able to shoot through the glass front of the court within a few feet of the players. This means being able to use wider lenses to bring the court into the picture as a frame. The only problem is that the player may not be isolated enough from the court and the other player. Here's how I dealt with that condition:

I shot the original image (right) with a 28mm f/1.4 lens set wide open while sitting on the floor very close to the glass. My shutter speed was 1/500 second at ISO 800.

Typically, squash courts have fluorescent lighting, and I found that neither the Fluorescent nor the Auto white balance setting consistently delivered an image completely free of the notorious green colorcast. So, I set a custom white balance.

Later in the computer, I isolated the main player by outlining him with the Lasso tool in Photoshop and then the Select Inverse function as in the tennis shot. I then applied the Edge Glow #3 setting from the Light section of Tiffen's Dfx software.

To extend the isolation even further, I converted the rest of the picture to a yellow monochrome using the Nik Color Efex Duplex Color filter (Duplex Color > Diffusion 75%, Saturation 75% Contrast 50%).

Finally, to give the picture some sense of motion, I applied a subtle zoom filter effect only to the background in Photoshop (Filter > Blur > Radial Blur > Zoom).

MONOCHROME IMAGES

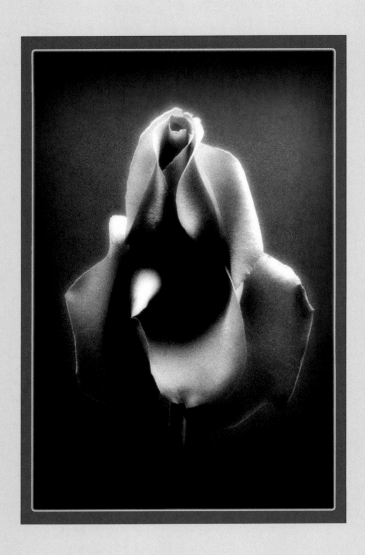

Rose

Like most photographers, I enjoy photographing flowers and flora. I tend to be attracted to the wonderful shapes and contours of flowers with large petals, such as roses. In order to bring out these qualities, I have found that eliminating strong colors and using a monochrome rendering is a good first step. I will often then use filter treatments that enhance the effects of light on the contours and shapes, as well as soften the overall appearance to emphasize the soft nature of flowers.

I used a 200mm macro lens for the original capture (left) and converted the color capture (left) to mono-chrome in Nik Silver Efex Pro, using the Orange filter. This warm filter translated the red color (which normally translates somewhere around medium gray) to variations of lighter tones depending on how the light fell on each of the petals. I used to do a lot of close-up photography using Tri-X film, so I decided to give the image the look of Tri-X 400 Pro using the Film Selection feature available in this software. The slightly grainy look produced in the final image was complemented by the overall smooth, almost creamy look so characteristic of the Tri-X films recreated by the Silver Efex software.

To add a hint of color, I used the E6-41 Orange Light cross processing selection in Pixel Genius Photokit.

I then added Tiffen's Dfx Edge Glow (Light > Edge Halo #10), which brought out the soft look of the rose even more.

The vignette came from Tiffen Dfx (Lens > Vignette > Rectangular Black), which allowed me to independently control the amount of shading on the X and Y-axis.

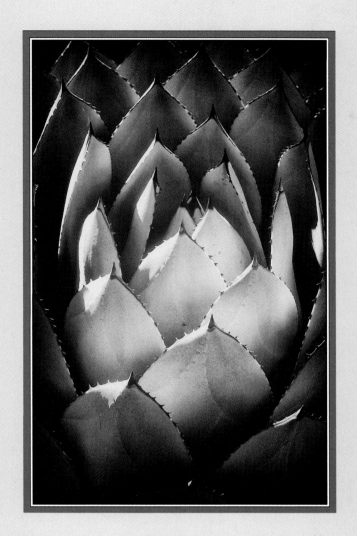

Cactus

In the case of the cactus, I was also attracted to capturing the shapes and contours of the fleshy leaves. With this plant, however, the thorn-like structures on the edges convey a very different impression than the rose, so I avoided using any soft focus effects in favor of sharp focus. This preserved the prickly nature of this plant. I was also attracted to the different levels of light intensity and shadow covering the plant. Specifically, in the upper and lower sections, the shade areas really brought out the sharp-edged nature of the plant, while the more even light in the middle perfectly conveyed its thick, fleshy makeup.

This was an easy image to render in its final form, as I only wanted to refine a few of the original image's visual qualities (left). As with the rose, the mono-chrome conversion was done in Silver Efex Pro, but this time selecting the Antique Plate I conversion, which gave me the slight color I wanted along with a built-in vignette framing.

I then used the Structure function of Silver Efex Pro, setting it to 75 to add texture.

I also did additional sharpening in Photoshop to boost the prickly look.

At the last minute, I decided to boost the warm tone of the Antique Plate I with some additional Sepia toning in Silver Efex Pro.

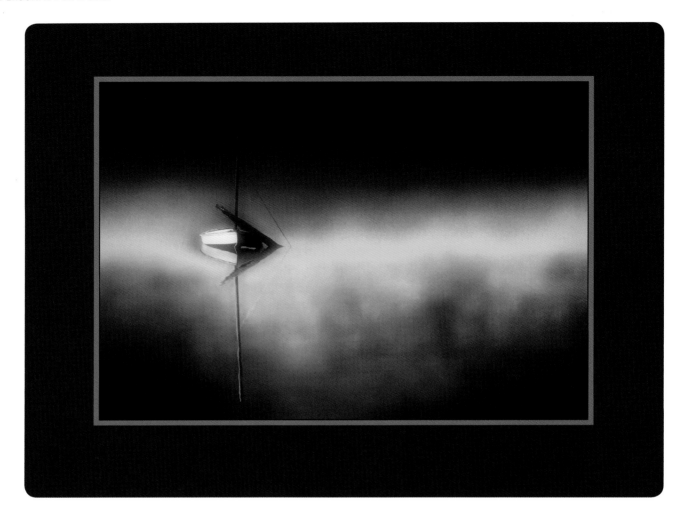

Sailboat

This picture—used as a demonstration photo back on page 83—really looked more like a monochrome image originally since the colors were so weak. I felt that the interplay between the boat and the fog coming off the lake was what the picture was all about, but there were factors competing with this relationship. I did not like the strip of trees along the far shoreline, and felt the lower half of the picture needed to be reduced in importance so as to isolate the boat and fog as much as possible.

I converted the original image (left) to black and white using the Neutral selection in Nik Silver Efex Pro.

In the HFX/Grads section of Tiffen Dfx software, I applied a #2 Tobacco strip filter effect to create the extreme monochrome warm tone I wanted.

To get rid of the influence of the tree line, I used several applications of the Burn Tone tool in Pixel Genius PhotoKit Color. To further isolate the boat and fog, I gave the bottom of the picture a similar amount of burning.

Lastly, I used a single application of the Andromeda Scatterlight Landscape Halo filter to reinforce the sense of atmosphere from the surface fog.

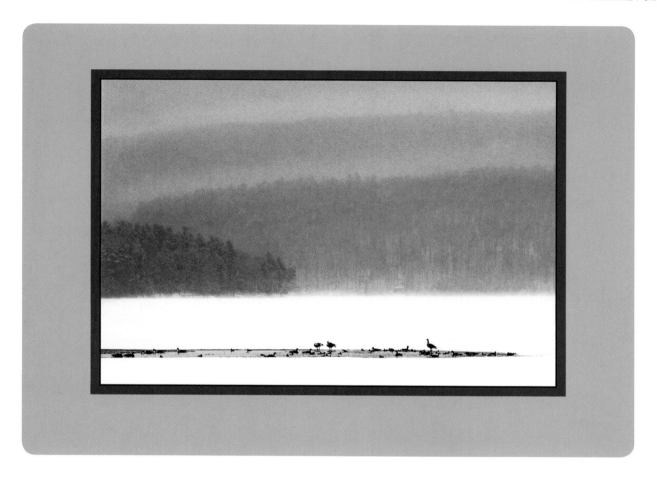

Geese on the Lake

When I shot this original picture of geese on a section of open water in a frozen lake (below), I thought setting the camera's white balance for Tungsten would produce a blue color cast that would reinforce the winter setting. The Tungsten white balance certainly produced that effect, but I did not like the way the picture looked. So, in the RAW file reader, I tried all the other white balance settings, and the warmest setting (Cloudy) seemed to have a better look. Once I saw this color change, I decided to shift the image to monochrome and look for a stronger overall warm tone, which turned out to be the brown seen in the final picture, above.

I desaturated the original image (left) and adjusted the contrast in Photoshop's RAW file reader making extensive use of the dark and light adjustments using the Curves tool to build up contrast and have the layers of the hills stand out.

The brown tone I selected was from Pixel Genius PhotoKit (PhotoKit > B&W Toning > Brown Tone). I used two applications of this filter over the whole scene, which created a slight brown colorcast in the white snow areas of the lake.

To neutralize the snow areas, I selected them in Photoshop using the Lasso tool and used Digital Light & Color's Color Mechanic Pro, to remove much of the brown colorcast.

Looking at the nearly complete image, I felt that the hills in the background were dark enough but too smooth in appearance. So, I selected that whole area in Photoshop and added a small amount of noise for texture (Photoshop > Filter > Noise > Add Noise > Gaussian, Monochrome, 5%).

 Index